Easy
Weekend Carving
Projects

by Tina Toney

FOX BOOKS

Fox Chapel Publishing Co Inc.

Box 7948
Lancaster, PA 17604

© 1996 by Fox Chapel Publishing Company Inc.

Publisher: Alan Giagnocavo
Project Editor: Ayleen Stellhorn
Desktop Specialist: Robert Altland, Altland Design
Cover Photography: Bob Polett, VMI Communications
Step-by-Step Photography: Marvin W. Pierson

ISBN # 1–56523–084–1

To order your copy of this book,
please send check or money order
for $12.95 plus $2.50 shipping to:
Fox Chapel Book Orders
Box 7948
Lancaster, PA 17604–7948

Try your favorite book supplier first!

Table of Contents

A Word from the Author

I started carving in 1982 when a course on relief carving was offered through a local community college. Prior to this course, I attended basic drawing classes, decorative art and landscape painting seminars, searching for an art form that truly captured my interest. That first relief course did spark a glimmer of interest, attracting me enough to attend a second quarter and a third.

Soon I was engrossed, attending every carving seminar available. Realistic songbirds, shorebirds, ducks, fish and caricatures have given me more experience. I continue to attend workshops on a regular basis, learning new things, enjoying the fellowship, seeing old friends, making new friends and, above all, sharing knowledge.

Ron Ransom sneaked into my life and introduced me to carving Santas. Soon I was designing and with time have developed a style of my own. Santas became my best seller in the co-op art gallery in which I displayed song birds and relief carvings. After six years of producing Santas for the gallery and other gift shops, I said enough! It was time to attend more wood carving shows and experiment with new designs.

My advice to you is to attend wood carving shows, become an active participant in carving clubs and enter competitions. To carve alone, without input from others, often slows your progress. Learn basic drawing skills. Acquire and practice safe carving habits.

Use your imagination, keep an open mind and don't be afraid to make mistakes on your projects. It is only a piece of wood, without feeling, waiting to be shaped by your hands. Mistakes are inevitable, and I made and repaired several during the carving of *Humpty Dumpty*. They weren't repaired without mention nor hidden from you.

I hope that *Easy Weekend Carving Projects* will provide you with a fun learning experience and instill in you the confidence to continue carving and the desire to experiment. Enjoy!–*Tina Toney*

An Introduction

Welcome to *Easy Wood Carving Projects* using commercial sugar pine wood turnings. *Easy Weekend Carving Projects* has been designed for the beginning wood carver.

Your favorite craft store provides ample materials for wood carving these days, with a wide variety of tools, paints, finishes and carving materials, including sugar pine wood turnings. A word of caution! Not all turnings are sugar pine. Many are hardwoods, such as maple, birch and ash. Hardwood turnings are slightly heavier and beige in color. Sugar pine turnings range from a faded yellow, straw color to a more yellow tint with occasional large, pink streaks.

If your local craft store doesn't stock sugar pine turnings, ask the manager to contact the manufacturer or other wholesale distributors in the sources section on page 2 to order a supply for the wood carvers in your community.

Easy Weekend Carving Projects is my version of a folk-type style of carving on sugar pine turnings. I intend to lead you through the various aspects of turnings and wood selection. Foremost in this book, I hope to stress the recreational value of wood carving... not to fret if your work doesn't look like mine.

Draw the patterns onto the turnings as we progress through the carving projects. The patterns within this book have been transferred to the wood with a permanent marker for illustration purposes only. I use a pencil on all my work, drawing and erasing until satisfied.

Happy Carving!–*Tina Toney*

The Basics

An Introduction to Carving Sugar Pine Wood Turnings

What is sugar pine? It is one of the finest carving woods available on the market today. Sugar pine is a white pine, in this case Western white pine. It grows throughout the Pacific Northwest and Canada.

My husband was kind enough to turn sugar pine on the lathe for my projects for several years until I found commercial turnings available in craft stores.

Selecting the Wood
The wood characteristics of sugar pine are that it has a density of 27 pounds per cubic foot, a hardness classified as soft with poor split resistance and a moderate to very fine grain structure. Northern white pine

compares at 25 pounds per cubic foot, a hardness rating of soft with poor split resistance and very fine to coarse grain.

As with any wood, the hardness–or in this case the softness–varies with each piece. How do you tell whether one piece will be softer than another? Interestingly enough, the most reliable way to detect a difference is by weight. If one turning feels heavier than another, the heavier turning is usually harder. Generally speaking, the turning that is the lightest in weight and color will provide you with the softer turning. Please understand this method doesn't always work. I've acquired some pretty difficult light-

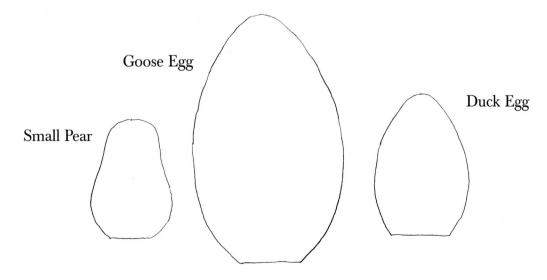

Small Pear

Goose Egg

Duck Egg

Sources for Turnings and Tools

Plum Fun Wood Products
5427 S.E. 72nd Avenue
Portland, OR 97206
(503) 777-3351, (503) 777-1126 FAX
 Manufacturer and distributor of sugar pine turnings (wholesale only), distributor of Tina Toney patterns

Stan Brown's Arts & Crafts Inc.
13435 N.E. Whitaker
Portland, OR 97230
1-800-547-5531
 Distributor of sugar pine turnings and artists materials (wholesale only)

Wood 'n' Feather
9701 N.W. 10th Ave.
Vancouver, WA 98665
(360) 574-2082
 Wood carving supplies, books and tools (retail sales)

Cascade Carvers Supply
198 Galaxie Road
Chehalis, WA 98532
(360) 748-7153
1-800-828-5576 (orders only)
 Palm chisels and knives courtesy of Cascade Carvers Supply

Chemifax
1-800-243-6329 Customer Service
 Manufacturer of Trewax. Trewax is sold at Ace, True Value, Target Stores, KMart, WalMart

Check your local craft stores. Ask the manager if you don't see something you need. Items often can be special ordered.

weight sugar pine turnings at times, too.

If you have a sugar pine turning that is difficult to carve, wrap it in wet paper towels, plop it into a sealed plastic bag and store it in the refrigerator for several days. Storing, in the refrigerator keeps it from molding. Note: Sugar pine is aromatic, so its scent will become stronger while wet. Between carving sessions, return the wood to the bag and refrigerate it, not allowing it to dry out until you have completed carving the project. Once the project is completed, let the wood dry completely before sanding and painting.

Tools and Materials
The best thing about carving sugar pine wood turnings, especially for beginners, is that you don't need a lot of fancy tools to make a beautiful finished project. For the projects in this book you'll need the following tools:

- a set of standard-sized palm chisels
- a quality wood carving knife

In addition to these tools you'll want to have the following materials on hand:

- a mat to protect the surface of your table
- a protective glove for the hand that holds the carving
- wood glue
- the paints, mediums and finishes listed in the project descriptions at the back of this book
- a Pigma .005 permanent pen

Setting Up a Work Space
Choose an area that is well-lighted with good ventilation. Avoid basement corners without windows and garages that are closed up. If you don't have enough natural light, you'll need a high-powered lamp to light your work. Good ventilation is important to dissipate the fumes from the sprays you'll be using. If you feel ventilation in your area is inadequate, improve it by installing a window fan.

Pick a comfortable chair or stool to sit on and a nice-sized work table. The table should be large enough to spread out all your tools and materials and

still leave plenty of room for you to carve comfortably. Protect the surface of the table with a router mat or non-slip mat purchased from a wood-working supply store. I've found that one router mat is large enough for several pieces.

Remove all distractions–or at least as many as possible–from your work area. Anything that diverts your attention from your carving, such as watching television, may lead to a slip of a tool and a damaged carving or a cut hand.

Above all, make your work area comfortable. A pleasant atmosphere will keep you relaxed and make you want to return to your carving often.

Sharpening Your Tools

Your top priority before you begin should be to make sure that your knives and chisels are sharp. Test all of your tools for sharpness on scrap wood. Sharpen them if necessary and use a leather strop throughout each carving session to keep the blades keen.

I won't go into sharpening here; it is quite involved and there are many methods. My best advice to you is to purchase a book on sharpening or take a class in which the instructor covers sharpening techniques.

There are two simple precautions you can take to avoid unnecessary sharpening. First, do not allow your tools to clink together in a tool box or whatever you may use for storage as this causes nicks and burring. Make covers for the knives and all chisels for protection during storage. And second, when switching tools while carving, lay the tools down carefully to avoid contact with one another. These precautions help to eliminate extra damage that may require heavy grinding to remove. Every time a tool has sustained a bad nick it requires extra grinding that in turn shortens its length and its life of use.

Laying Out a Pattern

Before you transfer the pattern to the turning, take a good look at the turning. Notice the arched rings of the wood grain. You'll want to locate the face of your subject over the center of these rings. The wood in this area is easier to carve, and you'll have a more aesthetically pleasing carving if you choose to use a

natural finish on the turning.

Once you've decided where to put the face, use a pencil and divide the turning into quarters. Stand the turning on end and draw the first line through the arched rings. Draw a second line at a 90-degree angle to the first. (See *Figures 1* and *3* on page 9.) These lines will help you to transfer the pattern to the turning.

I've found that using the traditional method of onion skin and carbon paper to lay out a pattern on a turning can be quite difficult and very time consuming. Flat pieces of paper do not usually conform well to egg- and pear-shaped objects. Proportions are easily distorted.

My suggestion is to draw the pattern onto the turning freehand. Simply eyeball the pattern and use a pencil to recreate those lines on the surface of the turning. Use the lines that you drew to divide the egg into quarters as guidelines.

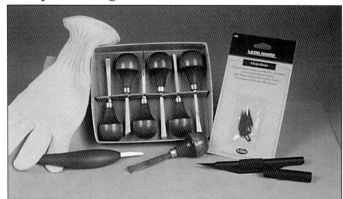

Choosing Tools

- Select a good quality set of standard-sized palm chisels. This one is a set of Harmon Tools.
- Purchase a quality knife that will last for many years. A Model Master knife handle and Testor's blades are shown.
- The mat shown is cut from a piece of router mat available from wood working supply stores. One router mat is large enough for several pieces.
- The glove is a Wizard Handguard made with the same fabric of which bullet proof vests are made. Wear it on the hand in which you hold your carving project. Caution: Never rely on this or any glove for total protection. Pretend you are not wearing any protective coverings and plan chisel and knife cuts with the emphasis on what may happen to the holding hand should the tool slip.

If you are uncomfortable with freehand drawing and would like to try your hand at using an onion skin and graphite paper, follow these suggestions. The patterns in this book show two sides–a front and a back–for each turning. Divide these in half again so that you are working with quartered patterns. Trace one quarter of the pattern on to a piece of onion skin. Place a piece of graphite paper between the onion skin and the turning and trace over the pattern lines with a pencil or stylus. Repeat this procedure three more times until you have transferred all four quarters of the pattern to the wood.

Sanding

To sand or not to sand? Generally, I prefer not to sand my pieces once I'm finished carving. I did, however, sand one of the pieces in this book–the cat carved on the goose egg. For this piece I wanted a very smooth finish because one normally thinks of cats as being soft and smooth. A bit of sanding on the cat allowed

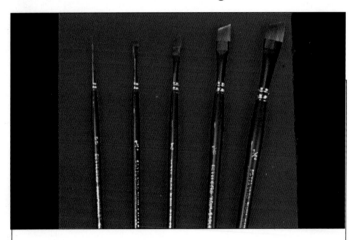

Painting Supplies

- Brushes: 0 round detail, 3/8" and 1/2" angular shaders. The brushes here are Bette Byrd "Aqua Sable" angular shaders and round details
- Materials: water container, wet palette, Pigma Pen 005, stylus, lint free cloth, paper towels, Trewax Floor Paste Wax in Clear and Indian Sand
- Paints: various paints according to the project you choose to carve
- Mediums and Finishes: Krylon Spray Varnish Satin Finish #1311, Jo Sonja's Tannin Blocking Sealer, Jo Sonja's Satin Finish Brush-on Varnish, Jo Sonja's Flow Medium, Jo Sonja's Retarder and Antiquing Medium.

me to better represent this animal in its natural state, but still have a folk-style feel to my finished piece.

If you do decide to sand, keep your tools sharp and use a fine 400-grit sandpaper. Also be aware that sanding embeds grit into the surface of the wood carving. As a result, using your knife on a sanded carving will dull the knife. Make sure you are *completely* done using your tools on your carving *before* you begin sanding.

Painting

I prefer to use acrylic paints for all my carving projects. I find that they are quick to dry, easy to find and available in a wide variety of colors (which eliminates the need to mix special colors).

It is important to note, however, that acrylics work best when used in conjunction with a medium. The medium helps to give you better control over the paints as you apply them to the turning by retarding drying time and making them more workable.

In this book, I use mediums in two ways. The first way is to apply the medium directly to the surface of the wood with a paint brush and then paint over the medium while it is still wet. The second way is to load the brush with medium and then add a bit of acrylic paint to the brush. You'll see more of how to use mediums as you work through the demonstration.

Finishing

I use several different types of finishes throughout this book. A spray satin finish is ideal for fixing the ink from permanent markers before applying a brush-on satin finish to the entire piece. I apply an additional wax finish to my pieces to give them an antique look, though you may opt to skip this step.

Signing Your Work

Upon the completion of my carvings, I sign and date the piece behind the sleeve, below the belt or in any tucked away place.

It's always a good idea to paint the bottom of the finished carving, but not seal it. This allows the wood to breathe. Display finished carvings away from high humidity and heat sources. Wood carvings need a stable environment with minor changes in humidity and temperature.

A Practice Session

Some Simple Carving Exercises Before You Begin

The first objective for the beginner is to learn basic tool usage. The following exercises will acquaint you with the proper hand positions required to manipulate your tools. Study the illustrations carefully before beginning each exercise. Also be sure to read the information in the Safety First section of this chapter before you begin.

For these exercises, I have used a small pear, though any small pine turning will suffice. I suggest repeating these exercises several times before beginning the step-by-step demonstration in the following chapter. The exercises will help you become familiar with carving on a rounded object.

It is not necessary to have a complete pattern on the practice turning. Study the grain direction before drawing the practice lines. Look to either side of the turning where the growth rings form a complete circular or pear shape. Draw a straight line, A, through the center of these oval rings down to and across the bottom of the turning. Locate line B 90° to line A. This is the first step for drawing a pattern on a turning.

Let's begin by laying your project on the non-slip mat. The mat is your third hand, providing a non-slip surface on the table in addition to gripping the project as you apply downward pressure with the holding hand, in this case, the left hand. Practice using your gloved hand to hold the project to the mat. Use a glove every time you carve but do not rely upon it as protection. Practice proper hand placement. always wear a glove, but pretend it's never there.

Exercise #1

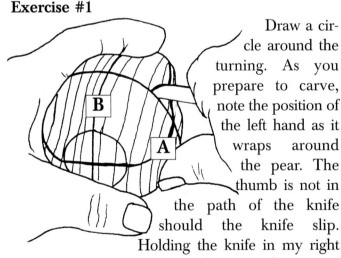

Draw a circle around the turning. As you prepare to carve, note the position of the left hand as it wraps around the pear. The thumb is not in the path of the knife should the knife slip.

Holding the knife in my right hand, I have braced my thumb against the pear to make a stop cut on the line. Bracing adds leverage through the wrist which utilizes and enhances the strength of the hand. Most importantly, however, is the control you have over the tool. Using your shoulders, both arms, elbows, hands and upper body properly is akin to a science class with the emphasis on mechanics. The dictionary defines mechanics as "a branch of physics that deals with energy and their

effects on bodies."

As you stop cut, push the knife tip straight into the wood for a short distance. Lift the pear slightly, rotate it and return it to the mat before you continue the stop cut. Always manipulate your project's position according to your upper body position. Your body is the machine with the energy to apply controlled forces to inert objects, in this case a turning. However, improper body usage on any project, especially round, can cause loss of control. During this moment, all the force you are applying to the turning breaks loose as uncontrolled energy against anything in its path, be it your fingers, hands or your now not-so-inert project as it tumbles away.

Exercise #2

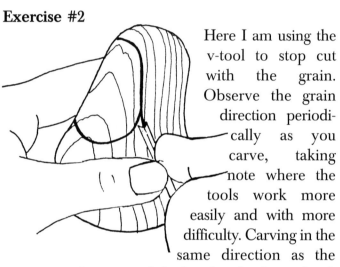

Here I am using the v-tool to stop cut with the grain. Observe the grain direction periodically as you carve, taking note where the tools work more easily and with more difficulty. Carving in the same direction as the grain is easily accomplished with a knife or chisel. However, it is more difficult to cut across the grain on the B side with a v-tool than the knife. Try other approaches, such as changing angles and using different tools. Use the v-tool, cutting across the grain on the A side of the turning. It's considerably easy because the rings are spread apart with the softer layer more exposed. Study the oval shape of the arch rings on the two sides of the turning, associating them with easier places to carve.

Continue this lesson by drawing two lines at least ³/₈" apart around the turning. Practice using the knife to stop cut one line. Use the v-tool for the other, following the line with the center of the tool. You will carve the line away with it in the center of the chip. As you carve a path across the turning, the ditch bottom becomes the lowest level of the stop cut. Carving across the grain where it layers in vertical rows is quite difficult with a v-tool. Yet it wasn't as hard in the wider growth ring areas. Try the v-tool in the easier to carve areas as much as possible then reinforce these stop cuts using a shallow knife cut straight into the center of the ditch. Don't use the v-tool to stop cut any farther than below the first v-ditch.

Exercise #3

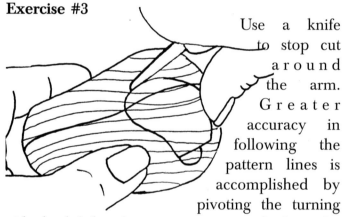

Use a knife to stop cut around the arm. Greater accuracy in following the pattern lines is accomplished by pivoting the turning with the left hand as you stop cut with the right. Holding the knife as shown in this illustration locks the wrist. Not only can you pivot the project with the left hand, but you can pivot your right hand, with the wrist still locked, at the point where your thumb touches the project. Another lesson in physics.

Exercise #4

Using the knife again, remove several layers up to the stop cut. Reinforce the stop cut, using the knife, to make a shallow, straight cut into the wood. Always make your stop cuts shallow, then remove a thin

Safety First

Your concentration must focus on your carving project and practicing safe carving skills. As a wood carving instructor, I caution the students often on proper tool usage to the point of sounding like a Myna bird who knows only one phrase. I feel the key to avoiding serious injury is to consider the safety of your hands above all. Then you will be more cautious in your approach to carving and less likely to injure yourself.

Easy Weekend

layer of wood up to the stop cut. Progress this way until you have carved to the depth you desire. This method prevents any unnecessary cuts into the wood that may show later.

What happens otherwise? When you reach a level that satisfies you and if you have set your stop cuts too deeply, they will show. Your natural tendency will be to get rid of them by carving them away, and then you'll have carved beyond your first depth. This turns into a viscous circle of having to carve more away than the pattern shows. If you don't control the depth of all stop cuts and reinforcement cuts, the result nearly always is to carve too deep into the project. If you have stop cuts showing after you reach your destination, stop then and there. Deal with these nicks when you have finished the carving. They are easily concealed with wood filler before the paints and sealers are applied.

Exercise #5

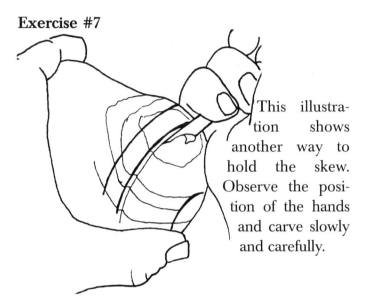

Here I have turned the wood and am bracing the knife with both thumbs. Try this and discover how much more punch and tool control you gain.

Exercise #6

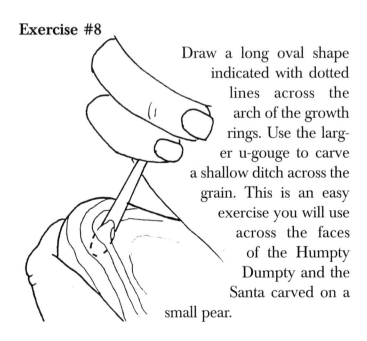

The skew is being used to remove wood from below the line for the belt. This tool enables you to carve at an angle across the wood grain plus get to the wood in tight corners. Using the pointed end of the skew, follow parallel to the belt line. Keep the back of the tool even with the same line. Your tools are important instruments with various specialties. Many carvers fail to use the skew due to lack of experimenting. I encourage you to use it; don't ignore any tool in the set of palm chisels.

Exercise #7

This illustration shows another way to hold the skew. Observe the position of the hands and carve slowly and carefully.

Exercise #8

Draw a long oval shape indicated with dotted lines across the arch of the growth rings. Use the larger u-gouge to carve a shallow ditch across the grain. This is an easy exercise you will use across the faces of the Humpty Dumpty and the Santa carved on a small pear.

Exercise #9

For this exercise, I am completing a Santa using the Testor's blade in a Model Master knife handle. Lay the blade flat against the carving, tilt the back slightly and remove chips shaped like fish scales overall.

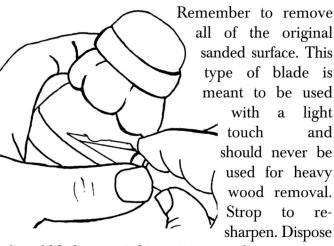

Remember to remove all of the original sanded surface. This type of blade is meant to be used with a light touch and should never be used for heavy wood removal. Strop to re-sharpen. Dispose of used blades in a tight container, such as an empty film canister, before discarding.

Consciously remind yourself of hand placement every time you change your tools and the way you intend to manipulate them. Practice using the other chisels holding them in the same manner as these exercises. Gouge your practice turning any and every way you can to gain as much knowledge of the wood properties and how to use the knives and chisels.

My last note of caution. Do allow yourself a rest as time has a magical way of passing without notice. Stop carving before becoming tired. The chance for injury becomes many times greater if you are fatigued.

Humpty Dumpty

A Step-by-Step Carving and Painting Demonstration

Beginning carvers are often at a loss as to where to start their carvings, and so they become overwhelmed before they even make their first cuts. In this demonstration, I will take you step-by-step through carving a sugar pine turning version of Humpty Dumpty, that loveable nursery rhyme character who takes a nasty spill. One side of the Humpty Dumpty turning will show a happy face, before the fall. The other will show a sad face, complete with cracks, after the fall.

To carve Humpty Dumpty you'll need the following tools and materials.
- one duck egg sugar pine wood turning
- set of palm chisels
- good quality carving knife
- Jo Sonja's Tannin Blocking Sealer
- acrylic paints in the following colors: Purple, Fire Red, Yellow, Medium Flesh, Rouge, White, Bonnie Blue, Brown Iron Oxide, Black
- 0 round detail brush, ³⁄₈" angular shader,

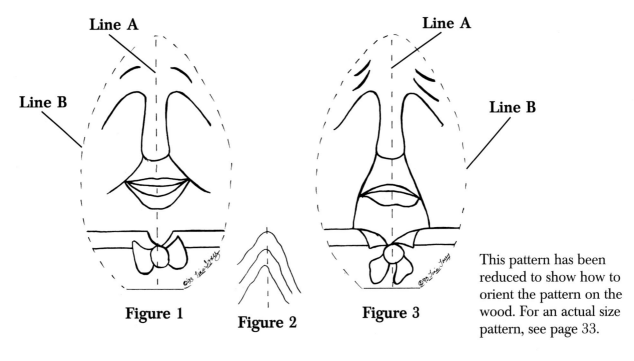

Figure 1

Figure 2

Figure 3

This pattern has been reduced to show how to orient the pattern on the wood. For an actual size pattern, see page 33.

1/2" angular shader
- Jo Sonja's Flow Medium
- Pigma .005 permanent pen
- Krylon Satin Finish Varnish #1311
- Jo Sonja's Satin Finish Varnish
- Trewax Floor Paste in Indian Sand and Clear

Transferring the Pattern

First locate the center line for the faces on the top side of the growth ring arch (*Figure 2*). Next, draw a line over the top and down the egg for the happy face (*Line A, Figure 1*). Then, using the line over the top as reference, draw another line at a right angle around the entire egg to divide it in half (*Line B, Figures 2 and 3*). These lines are represented as the outlined perimeter as well as the outline of the egg. (Note: Figures 1, 2 and 3 are not shown actual size. Turn to page 33 for a pattern of Humpty Dumpty at actual size.)

Next, copy the pattern on the duck egg with a pencil. I draw my patterns on the eggs freehand, erasing and redrawing until I am satisfied that the end result resembles the pattern as closely as possible. If you are not confident in your drawing abilities, you can use onion skin and carbon paper to transfer the pattern to the egg. This method is difficult and time consuming. For a description, see page 4.

Before You Begin

Carefully study the photographs below before you begin carving. They show the relationship between the finished piece and the turning with just the pattern drawn on. These photos should help you fix an image of the finished project in your mind and give you a clear goal toward which to work. Refer to these images often as you are carving as well.

When you're ready, let's begin.

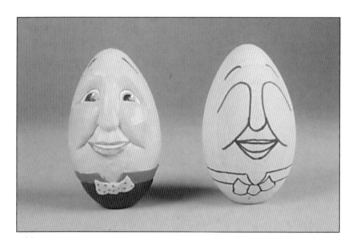
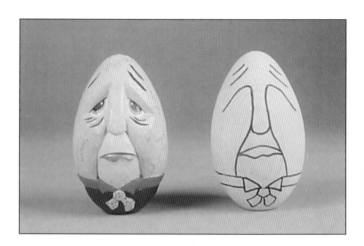
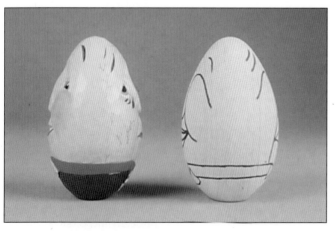
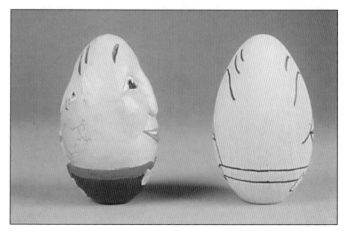

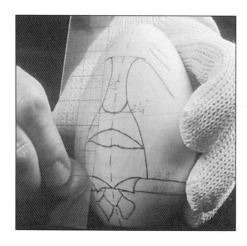

1. Use a flexible ruler to set the nose line 2¼" up from the table top. Draw the mark for the uppermost part of the eyebrow 1¼" above the nose line. Note: Do not press the ruler into the curve of the egg.

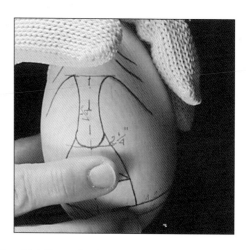

2. At the 2¼" mark, draw a line for the width of the bottom of the nose. It should be ½" wide.

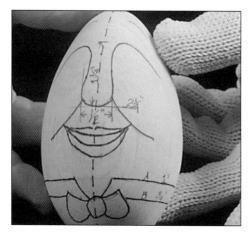

3. Measure for Lines A and B of the collar and the nose and eyebrows. Mark a large H above the eyebrows to designate this as the happy side. Round off the corners of the nostrils on both sides.

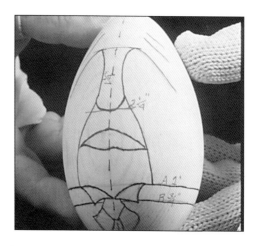

4. Mark a large S above the eyebrows on the opposite side of the turning to indicate that this is the sad side of Humpty Dumpty.

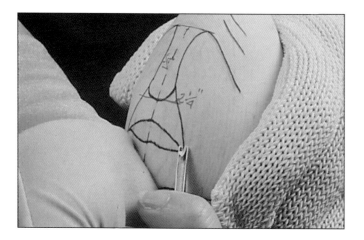

5. On the sad side, use the small v-tool on only the lines shown to create a v-shaped ditch.

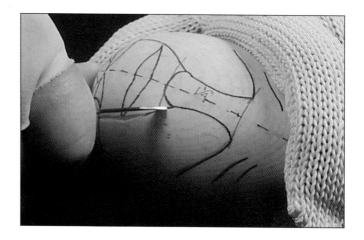

6. Use the bottom of the ditch as a guide for the knife to deepen the stop cut. Cut slightly deeper where the lines for the nostril and the cheek meet.

Carving Projects

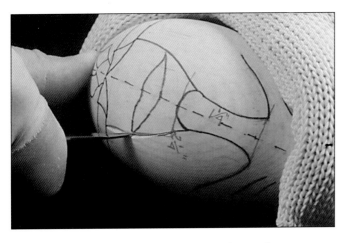

7. Continue to reinforce the stop cut by making progressively deeper cuts with the knife.

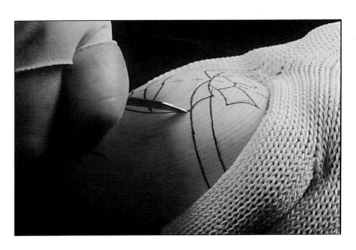

8. To make stop cuts using a knife instead of a v-tool, push the knife straight into the wood and pull it along the line.

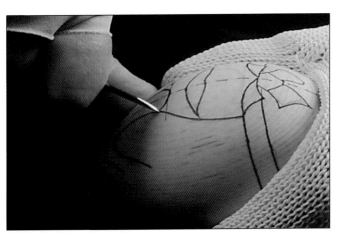

9. Continue up the cheek line with a knife to the corner of the nose. Then deepen the cuts at the corners by pushing the knife in a little farther and pulling it along the line again.

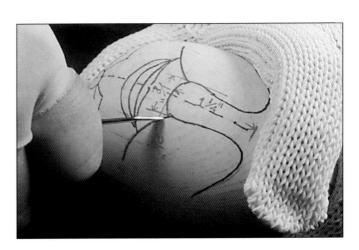

10. Moving back to the happy side of Humpty Dumpty, stop cut the cheek line using the knife.

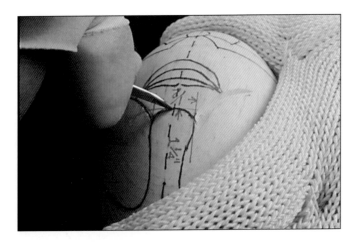

11. Next, stop cut around the nostrils and across the bottom of the nose.

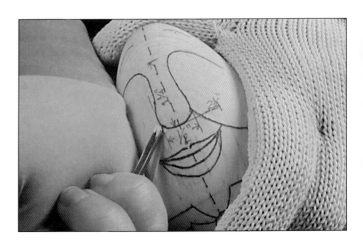

12. Here I am using a v-tool to make stop cuts with the alternate method.

12 **Easy Weekend**

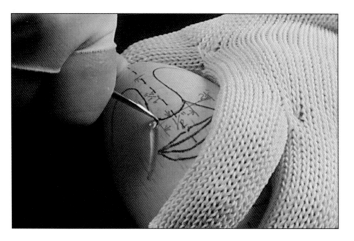

13. Use the knife to cut a triangle shape at the corner of the nose.

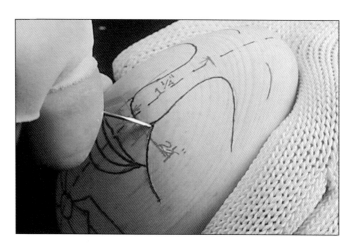

14. Stop cut with the knife.

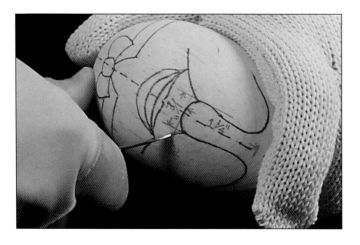

15. Stop cut at the cheek line.

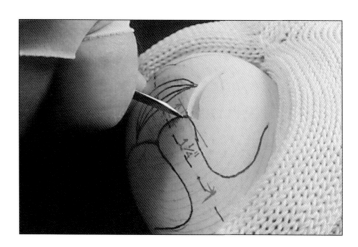

16. Stop cut at the nostril line.

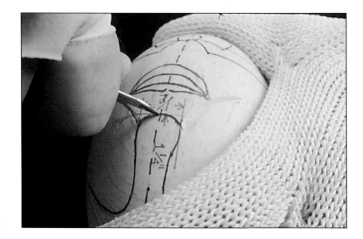

17. Stop cut across the bottom of the nose.

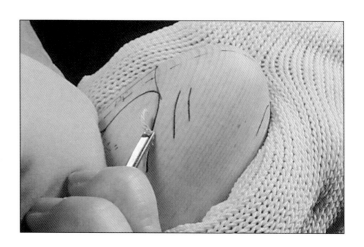

18. Use the v-tool to stop cut along the brow lines on the sad and happy sides.

Carving Projects

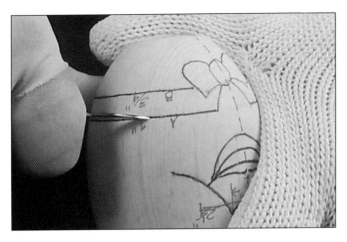

19. Use the knife to stop cut across the grain on Line A.

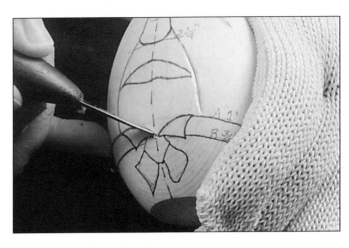

20. Stop cut deep by the bow tie.

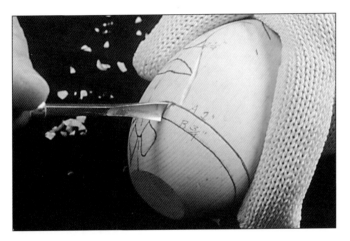

21. Use a u-gouge to make the stop cuts along the collar. Note: Push the u-gouge straight into the wood and rock it back and forth in the stop cut. But never twist it side to side as you may break the gouge.

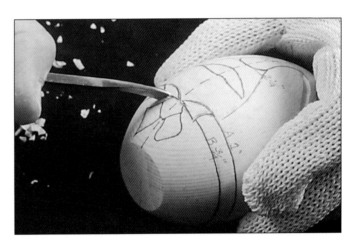

22. Continuing using the u-gouge to make stop cuts around the upper portion of the bow tie.

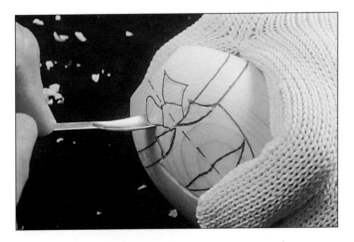

23. Use the u-gouge on the curved lines around the lower part of the bow tie.

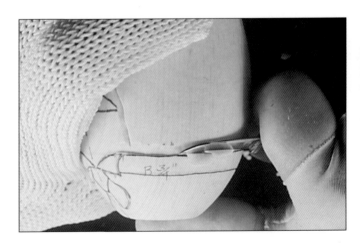

24. Use the knife to relieve wood above the collar line. Make shallow cuts to remove wood up to your stop cut.

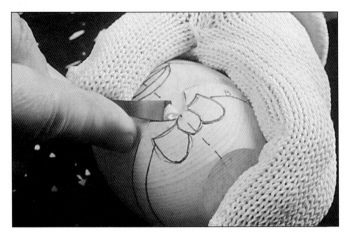

25. Switch back to the happy side and use the skew around the collar tips.

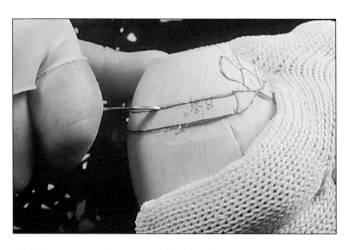

26. Stop cut on Line B with a knife.

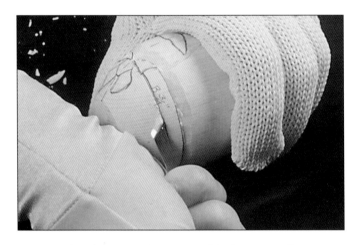

27. Use the skew to relieve wood below Line B.

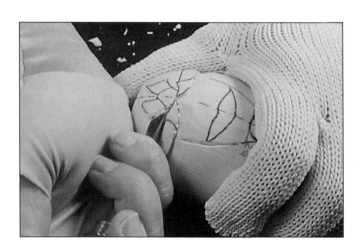

28. Move to the sad side now. Use the skew to reach into the corners of the bow tie.

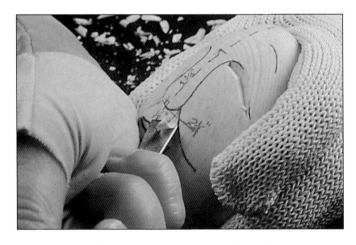

29. Turn back to the happy side and use the skew to remove the wood below the nose.

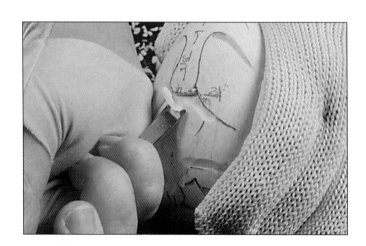

30. Continue under the nose. Note the chip I accidentally carved away. You may opt to glue the chip back in place if its placement is critical or to disguise the resulting dent. I'll fix this one with a knife later.

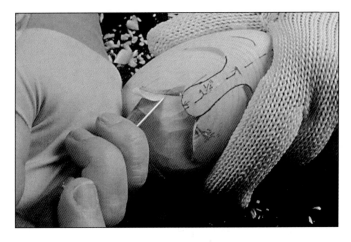

31. Deepen the area under the nose and beside the cheeks.

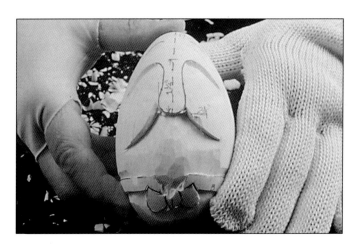

32. The resulting cuts will leave a mound of wood for the mouth area.

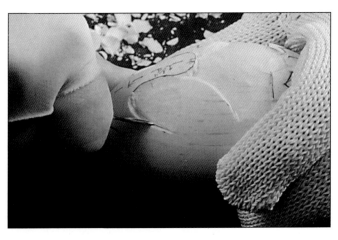

33. Using the angle of the v-shaped ditch as a guide, take your knife as shown to deepen the slope below the brow line.

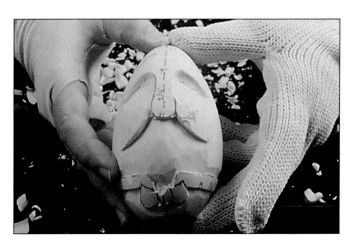

34. Follow this most recent cut with a large u-gouge to create the dished out area below the brow line. Use the 1/2" sweep to carve wood from the upper cheek to the eye to create a slope to the bridge of the nose.

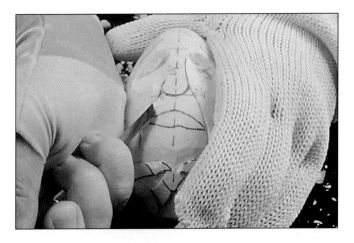

35. Turning the egg over, use the skew and repeat the same steps on the sad side.

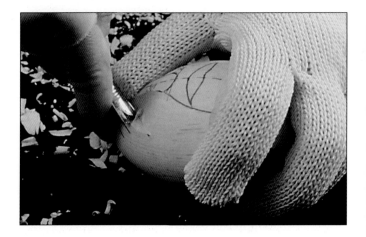

36. Scoop out the area below the brow line with the large gouge.

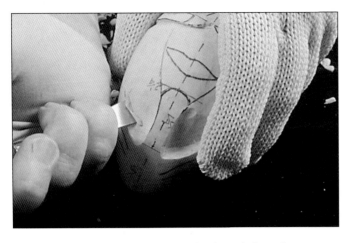

37. Follow up with a sweep to further define the area.

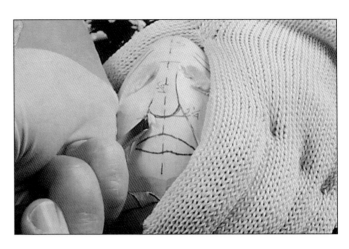

38. To work the corners between the nose and the cheek, use a skew.

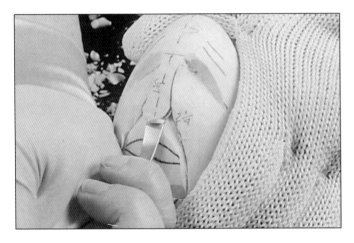

39. Remove wood under the nose.

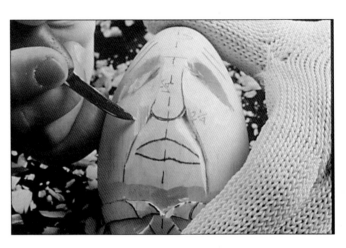

40. Note the chip I lost right here on the cheek of the sad side. Several more steps and it will be corrected.

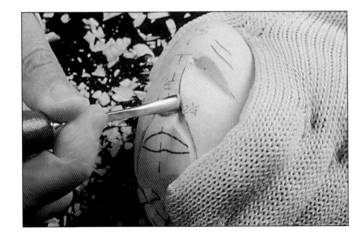

41. The large u-gouge can be used to make this stop cut. On the happy side, I used the knife to make this stop cut around the nostril. Here on the sad side, I'll use a large u-gouge to make the stop cut.

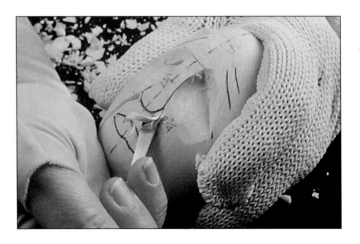

42. Use the skew to remove more wood from this area.

Carving Projects

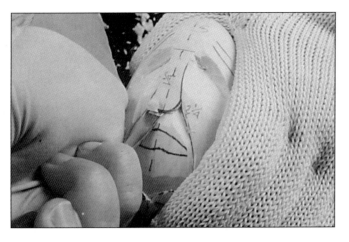

43. Turn the skew and work the opposite corner.

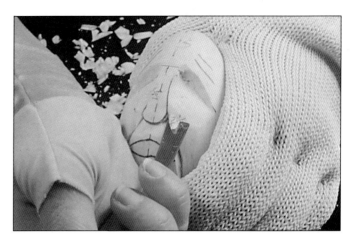

44. Now I'll deal with the lost wood on the cheek. To correct it, I'll simply use a sweep to equalize the cheeks.

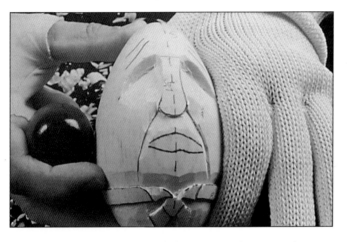

45. Both cheeks are now balanced, and I'm ready to move on.

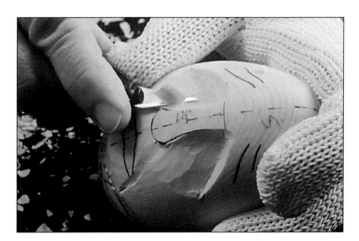

46. Continuing on the sad side, use the knife to slope the wood from the cheek to the nose. These cuts allow the nose to protrude from the surface of the egg.

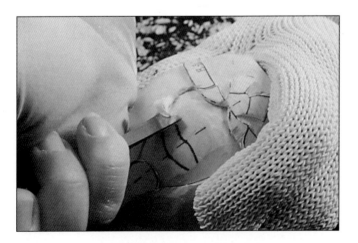

47. Use the sweep to remove wood below the mouth area. Remember to leave a mound for the mouth.

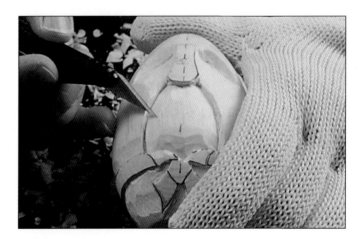

48. The mouth mound should be large enough to give you plenty of room to carve the mouth.

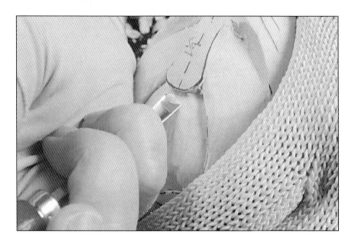

49. Staying above the upper lip, use the large u-gouge to ditch out wood under the nose.

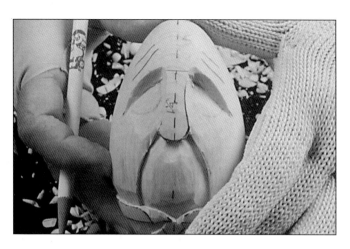

50. The mouth mound is nearly roughed out in this step. Now draw in the sad eyes.

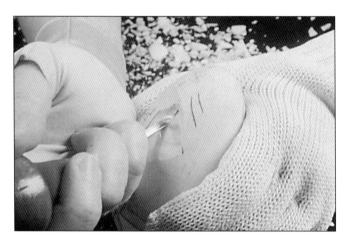

51. Use the v-tool to outline the eyes. Here I am following the eye line around the left eye.

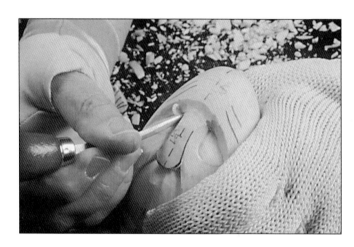

52. Repeat the same procedure for the right eye.

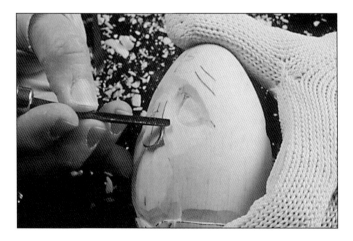

53. Note the ledges in the eye left from the v-tool. Use the knife to remove these ridges, creating a more flattened area for the eye. Don't carve a round eyeball, but one with just a small amount of curvature.

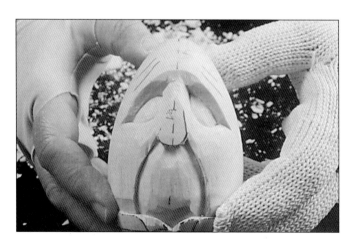

54. This photo shows the sad eyes after the edges have been cleaned up.

Carving Projects

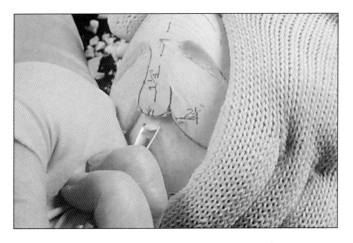

55. Moving to the happy side, make the ditch below the nose.

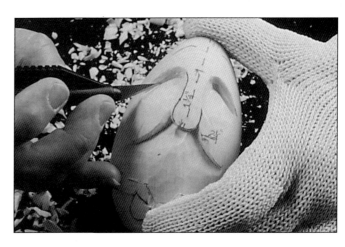

56. Next clean up the eye area with the knife. Draw on the happy eyes.

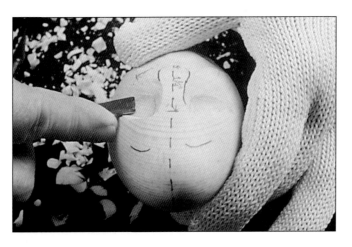

57. Use the u-gouge to make a hollow area for the eyes.

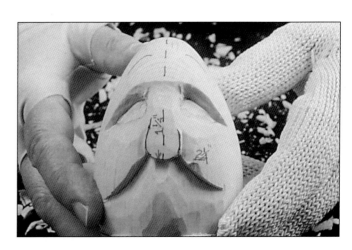

58. Re-draw the eyes.

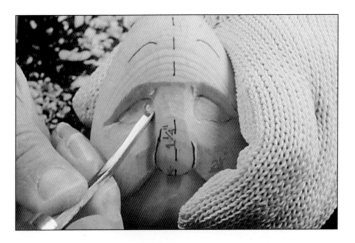

59. With a v-tool, start carving at the lower inside corner of the eye, moving upward following the upper eyelid.

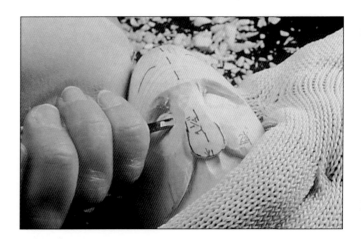

60. Outline the lower eyelid, moving from the outside edge to the inside corner of the lower eyelid.

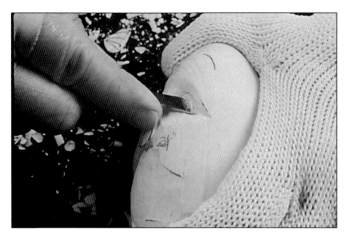

61. Use the skew to clean ridges off the eye surface. This leaves a ledge at the bottom of the eye. Using the knife, cut across these ledges, sloping the cheek to the bottom eyelid.

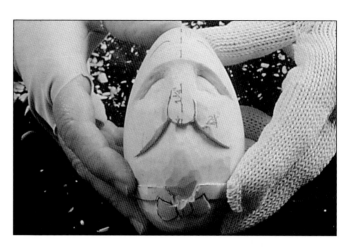

62. This photo shows the eye area completed.

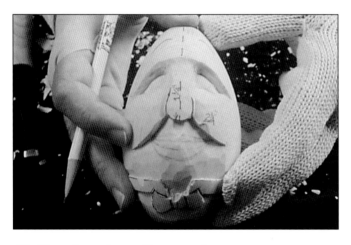

63. Next draw the smiling mouth.

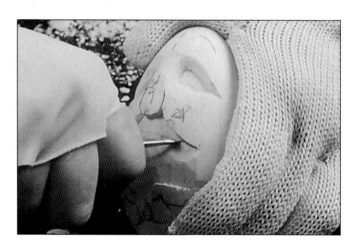

64. The bottom line of the upper lip becomes the guide for the next cut. In the corner, stop cut deep and, as you continue the stop cut across the mouth, make the stop cut more shallow. Deepen the other corner.

65. Using the knife, make a slightly sloping cut below the mid-lip area to the stop cut.

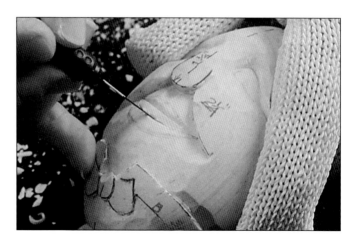

66. This photo shows the upper lip and the stop cut on the top line of the lower lip.

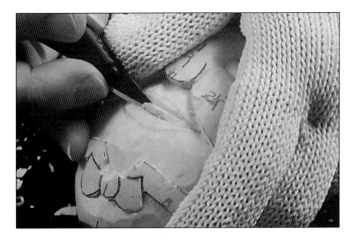

67. Use the knife to flatten the teeth area.

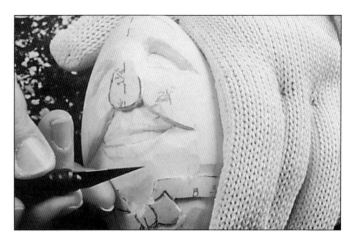

68. Deepen the stop cuts in the corners where the teeth recede behind the lips. Remove a triangle-shaped chip to allow the teeth to curve into the corners of the mouth.

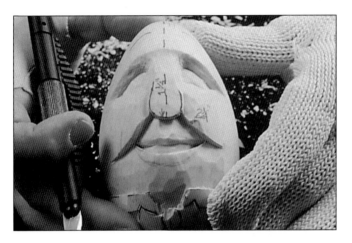

69. Here you can see how the teeth recede into the corners of the mouth.

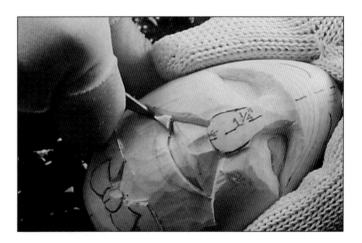

70. Use the knife to remove the wood below the lip. This sets the bottom lip slightly lower than the upper lip.

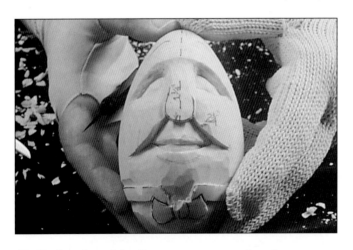

71. Both sides of the lips are now completed.

72. Use the u-gouge to sweep across the area below the lower lip line. Leave this line showing.

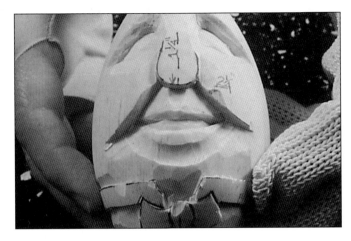

73. Continue the cut to the cheeks, only make it shallower as you reach the cheek areas. Use your knife to remove the puffy area below the bottom lip and the collar tips. Be careful here with the knife...

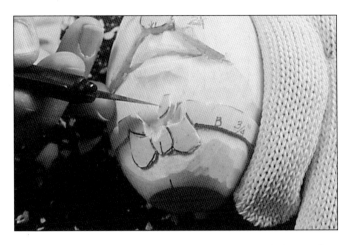

74. ...or this will happen. I was a bit lax and chipped off a part of the bow tie and collar. This is a major deal! I'll keep the chip and and show you how to glue it back on in the next two photos.

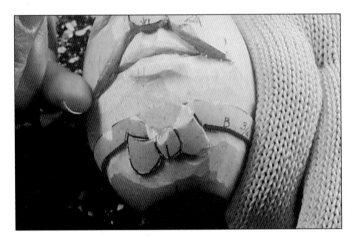

75. First I'll relieve the chin area then glue the chip back in place.

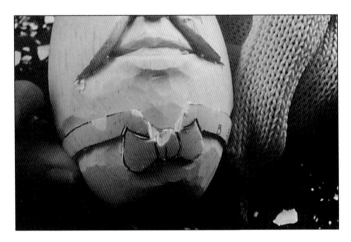

76. Allow the glue to dry while you are carving elsewhere. Hint: If a section of your carving chips off in several pieces, rebuild the area with wood filler and re-carve or sand.

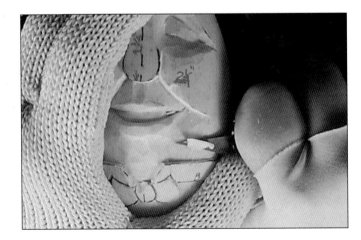

77. This is a good time to use the knife to remove the fullness in this area.

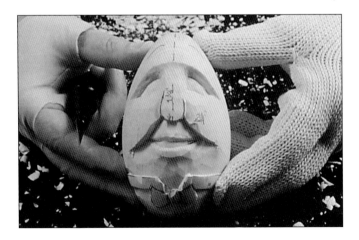

78. The lower chin area is now relieved enough for the present time.

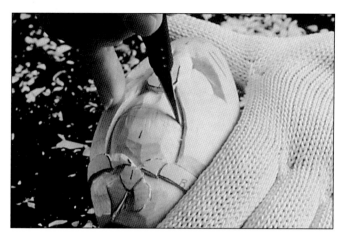

79. Move to the sad side and draw on the sad mouth. Use your knife to stop cut straight in on the line between the lips.

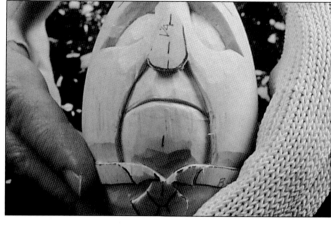

80. Using a knife angled toward the top lip, remove a sliver of wood across the bottom lip. This will set the lower lip beneath the upper lip. Do not round over the upper lip. We want to keep the ledge.

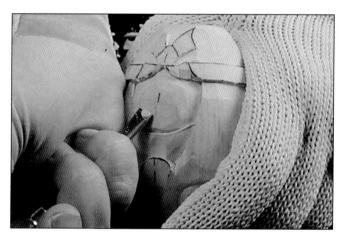

81. Use the u-gouge to remove a ditch at the lip where the line curves upward.

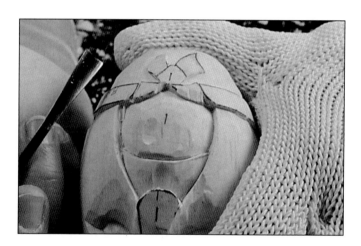

82. This cut gives a pout to add to Humpty Dumpty's expression.

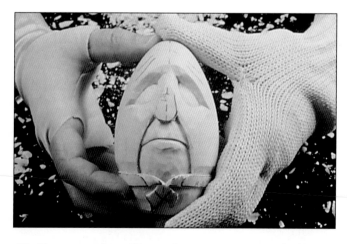

83. Pout complete. Shape the remaining area below the lip with a knife.

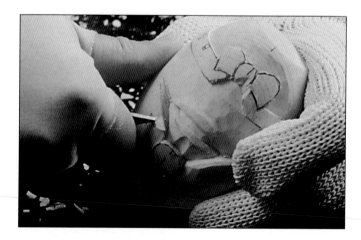

84. With the knife, round off the ledges of the cheek on the happy side.

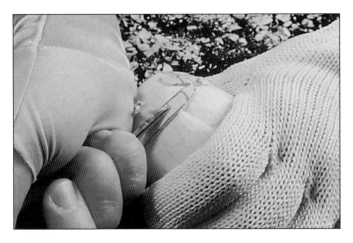

85. Use the skew as shown to remove the ledge at the bottom of the collar line.

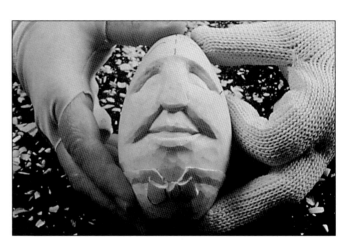

86. The cheeks have now been rounded to satisfaction.

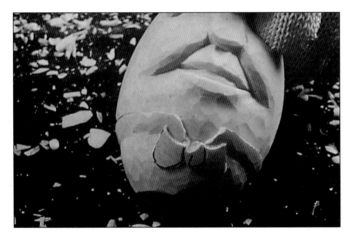

87. Ease the flow of the collar line into the body of the shirt.

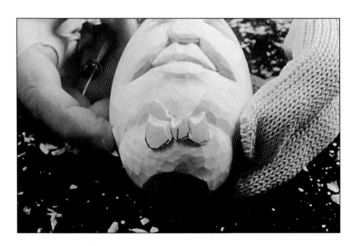

88. Start to remove the corners on the bow tie.

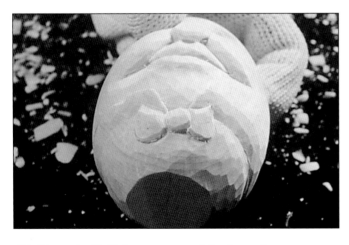

89. Round off all the corners of the bow tie.

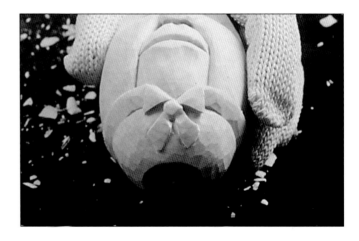

90. Go to the sad side. Use the same treatment to complete the sad bow tie.

Carving Projects

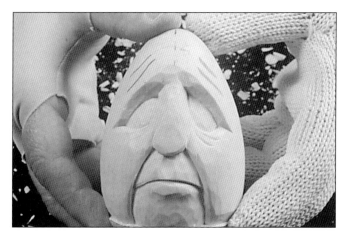

91. Continue by rounding off the corners on the nose. Draw the wrinkle and worry lines; carve them with a v-tool.

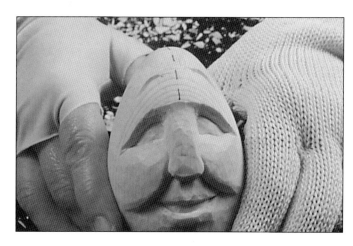

92. Moving back to the happy face, draw the happy wrinkles above the brow line. Carve these lines with a v-tool.

93. The Model Master shows its talent for removing wood from the sanded surface of the egg. Remove small amounts of wood with controlled cuts over the entire surface of the egg.

94. Use the knife to smooth the entire head right to the collar line.

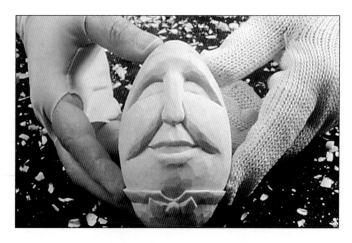

95. A completed happy side of Humpty Dumpty, one of several used during this project.

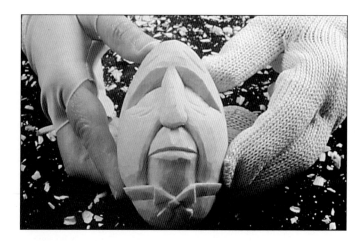

96. The sad side of the preceding Humpty Dumpty. This has been sealed with Jo Sonja's Tannin Blocking Sealer.

Painting Humpty Dumpty

Painting can be a daunting proposition for beginning carvers. For Humpty Dumpty, I've chosen a simple color scheme that will teach you the basics of painting, but not frustrate you with advanced techniques.

We'll start with simple base coats. Then we'll add details in blocks of solid colors. The only layering or shading of colors you'll be doing on Humpty Dumpty is on the cheeks. Even the layering in this area is optional, depending on your preference for dark or light cheek colors.

Details, such as outlining the eyes and adding cracks to the sad face, will be done with a Pigma .005 permanent pen. I find this pen is easier to control than a brush for such fine details. Practice using it on a piece of scrap wood that has been finished with the same methods as you used on your carving.

Finishing Humpty Dumpty

When the paints and ink are completely dry, apply a light misting of Krylon Satin Finish Varnish #1311. Allow this to dry and then apply a coat of Jo Sonja's Satin Finish Varnish.

To protect your carving, I suggest you apply a coat of wax finish. I'll be using Trewax Floor Paste in this demonstration. I'll apply a tinted wax first, called Indian Sand, then immediately apply a final clear coat of wax.

Whatever wax you use, be sure to let it dry thoroughly before buffing the finished piece. I suggest a soft, clean cloth or a soft-bristled shoe brush. Either will work well to give your carving a beautiful, polished glow.

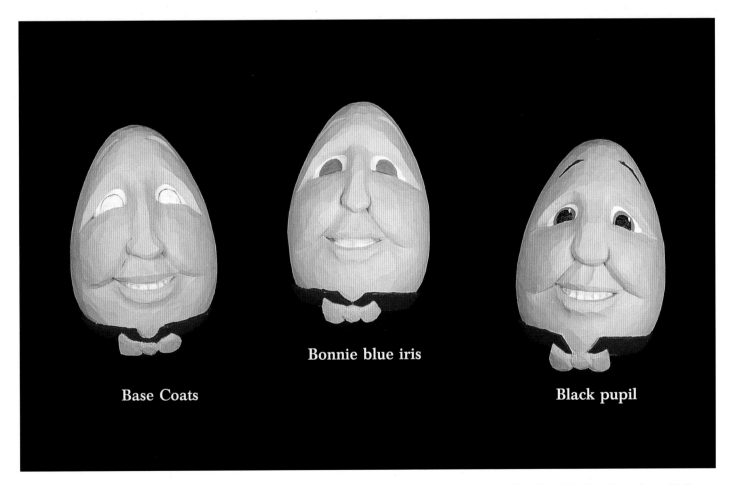

Base Coats

Bonnie blue iris

Black pupil

1. Base Coats: Base coat the bottom section of Humpty Dumpty with Purple, the collar Fire Red and the bow Yellow with Fire Red dots. Use Medium Flesh over the rest of the egg. When completely dry, paint the entire eye and happy teeth surfaces with White. Paint the happy and sad wrinkles above and below the eyes with Brown Iron Oxide.

Eyes: The Humpty Dumpty on the left shows the eyes drawn in and painted White. The middle one shows Bonnie Blue for the iris. The third carving shows a Black pupil with White highlights.

Using the pattern as a guide, draw the sad eyes on the other side and use the same procedures.

Carving Projects 27

2. The film canister lid contains Jo Sonja's Flow Medium. Rouge paint has been squeezed onto the palette. Load the brush with medium.

3. Pull some medium out of the brush by wiping it gently across a paper towel. The medium should not be runny or puddle. Brush on the happy cheeks to pre-moisten the area.

4. Repeat loading the brush.

5. Pull Rouge from the edge of the paint puddle.

6. Make several swipes on the palette to mix the paint and the medium.

7. Pull the excess moisture from the brush.

Easy Weekend

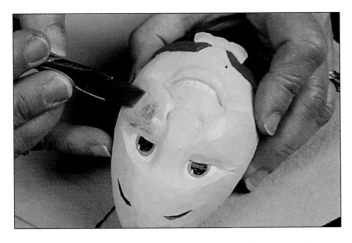

8. Apply the Rouge to the pre-moistened area of the cheek, blending the perimeter to give a softness to the area. If the paint is very light, allow it to dry completely, then repeat, building layers if necessary. Allow each layer to dry.

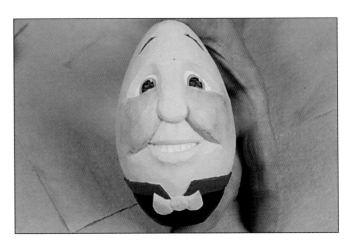

9. Dilute Brown Iron Oxide with water to a consistency slightly thicker than ink. Apply a watered-down wash of this color to the outside edges of the teeth where they recede into the mouth. Paint the lips with a strong Rouge.

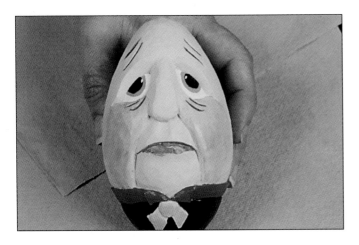

10. Does Humpty Dumpty appear pale? Pre-moisten the head sparingly with medium. Apply a very light mixture of Rouge and flow medium with a large brush over all of Humpty Dumpty's head surface.

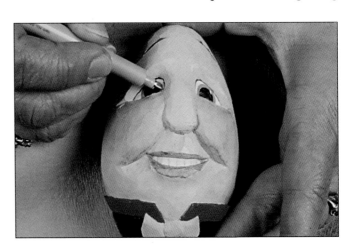

11. Use the Pigma .005 permanent pen to outline the top of the eyelid on the happy side. Don't outline the lower portion of the eyes on either side.

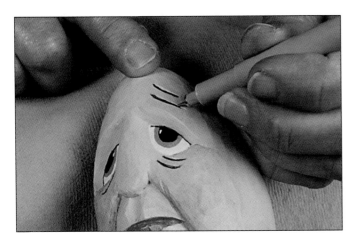

12. Here one of the sad eyes is completed. Accent the bottom of the ditch in the wrinkles.

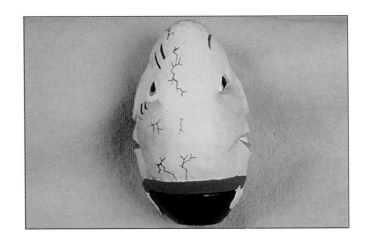

13. Use the Pigma pen to apply the black cracks to the sad side. Finish with a light misting of Krylon Satin Finish Varnish #1311. Allow to dry, then apply Jo Sonja's Satin Finish Varnish.

Carving Projects

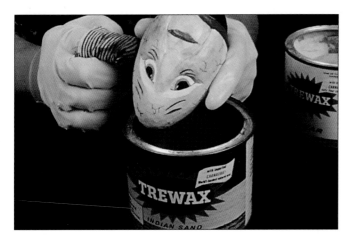

14. Use a clean cloth to apply Indian Sand Floor Paste Wax over entire head.

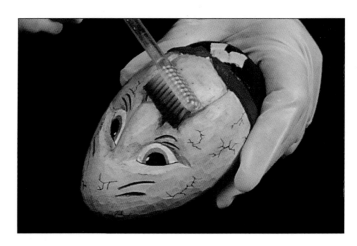

15. Use a toothbrush in hard to reach places. Do not let this dry!

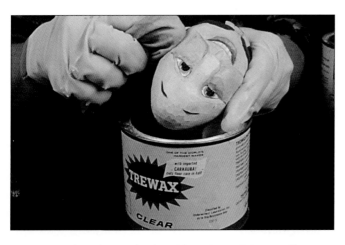

16. Immediately apply the Clear Paste Wax, pulling off the excess Indian Sand. Repeat this process, never allowing the wax to dry. When satisfied, allow the wax to dry three and a half to four minutes.

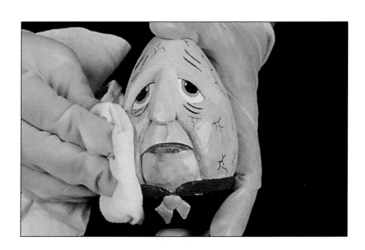

17. Buff the piece with a soft clean cloth.

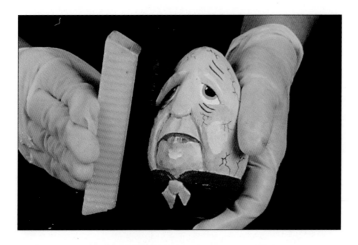

18. A soft bristle shoe brush works as well.

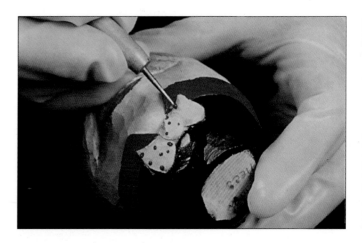

19. Oops. Forgot the red dots. I'll need to remove the wax with a cotton swab dipped in rubbing alcohol first. Note: Don't scrub or you'll remove the paint. Then I'll add the red dots, allowing them to dry, and re-wax.

Eight Easy
Weekend Projects

Humpty Dumpty on Duck Egg

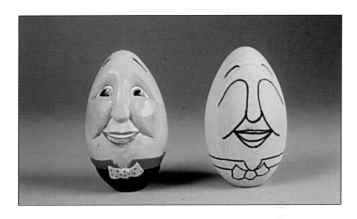

Materials: Duck egg sugar pine wood turning, set of palm chisels, wood carving knife.

Paints: Purple, Fire Red, Yellow, Medium Flesh, Rouge, White, Bonnie Blue, Brown Iron Oxide, Black

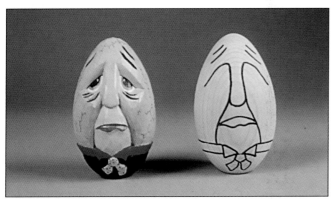

Mediums and Finishes: Jo Sonja's Tannin Blocking Sealer, Jo Sonja's Flow Medium, Jo Sonja's Satin Finish Varnish, Krylon Satin Finish Varnish #1311, Trewax Floor Paste in Indian Sand and Clear.

Carving Tips: See the step-by-step demonstration on page 9.

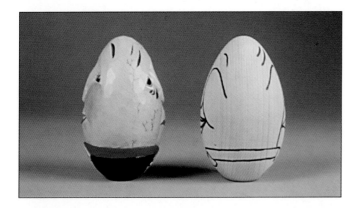

Painting Tips: See the step-by-step demonstration starting on page 27.

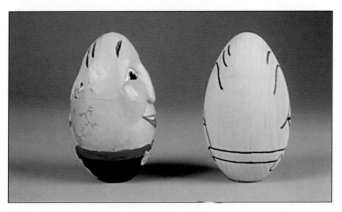

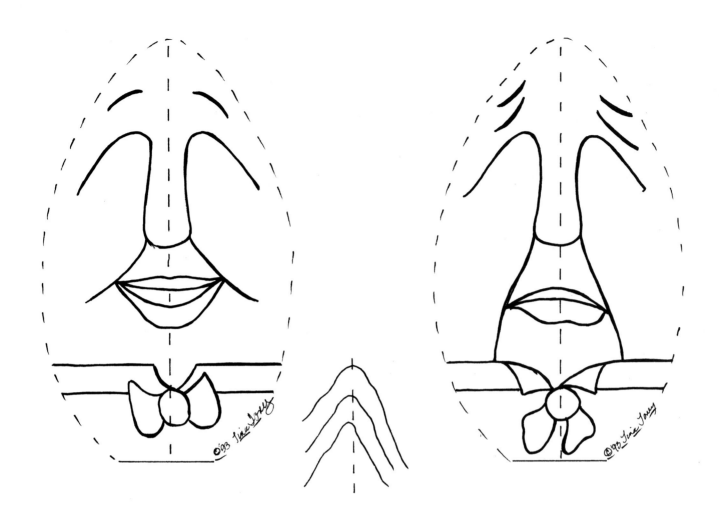

Carving Projects

Chicken Carved on Pear

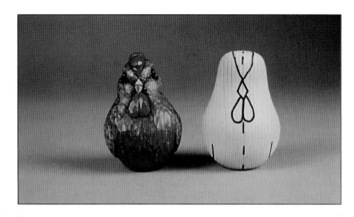

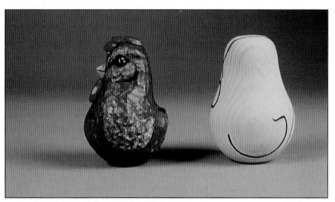

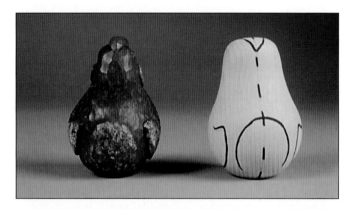

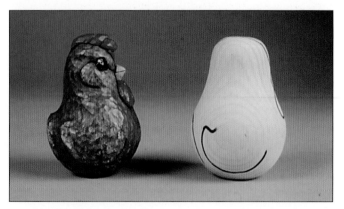

Materials: Pear-shaped sugar pine turning, carpenter's wood filler, set of palm chisels, wood carving knife.

Paints: Nightfall, Light Ivory, Fire Red, Pumpkin, Yellow, Brown Iron Oxide, Black.

Mediums: Jo Sonja's Tannin Blocking Sealer, Jo Sonja's Satin Finish Varnish, Trewax Clear Floor Paste Wax, Krylon Satin Finish Varnish #1311.

Carving Tips: Fill the pre-drilled stem holes at the top with wood filler. I carved a narrow comb on this chicken. Draw the wide one from the pattern so you have room to experiment.

Painting Tips: Seal with Tannin Blocking Sealer before painting, Satin Finish upon completion. A clear coat of Trewax adds a nice patina.
- Body: Nightfall, dry-brushed with Light Ivory applied with small fan brush.
- Fleshy Parts: Fire Red.
- Beak: Pumpkin, highlighted with Yellow
- Eyes: Brown Iron Oxide, black, White highlight and Pumpkin at inside corners.

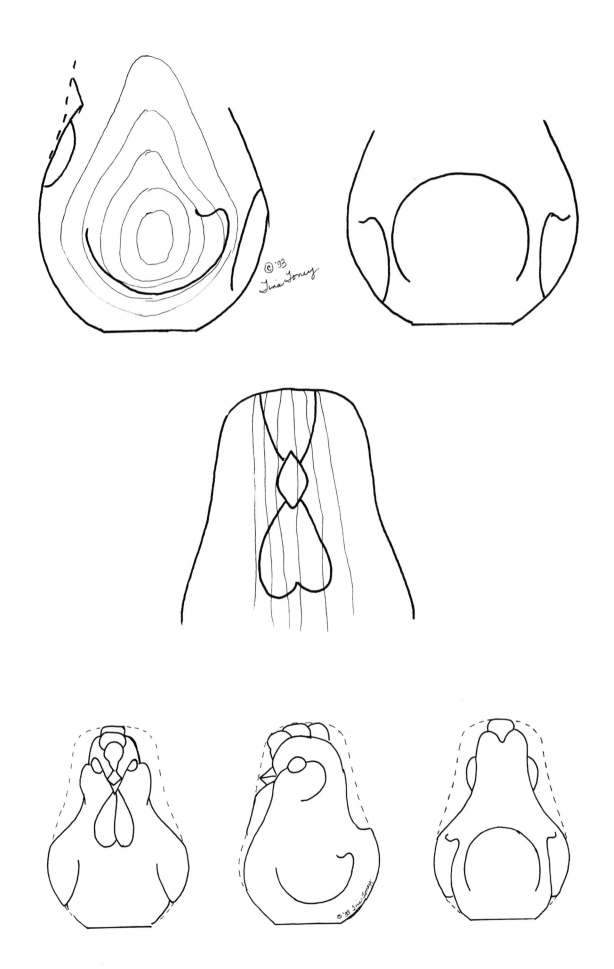

Chicken Carved on Goose Egg

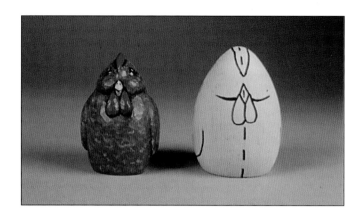

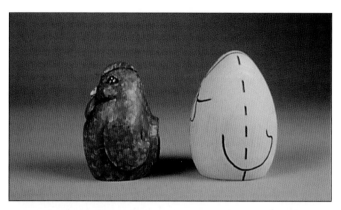

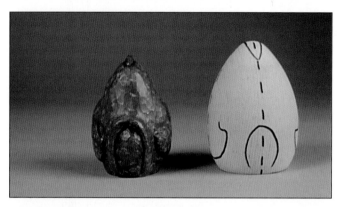

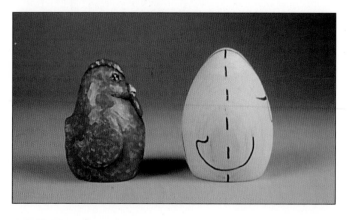

Materials: Goose egg sugar pine turning, set of palm chisels, wood carving knife.

Paints: Nightfall, Light Ivory, Fire Red, Pumpkin, Yellow, Brown Iron Oxide, Black.

Mediums: Jo Sonja's Tannin Blocking Sealer, Jo Sonja's Satin Finish Varnish, Trewax Clear Floor Paste Wax, Krylon Satin Finish Varnish #1311.

Carving Tips: Cut 1/2" off the bottom of the egg and sand it smooth.

Painting Tips: Seal with Tannin Blocking Sealer before painting, Satin Finish upon completion. A clear coat of Trewax adds a nice patina.
- Body: Nightfall, dry-brushed with Light Ivory applied with small fan brush.
- Fleshy Parts: Fire Red.
- Beak: Pumpkin, highlighted with Yellow
- Eyes: Brown Iron Oxide, Black, White highlight and Pumpkin at inside corners.

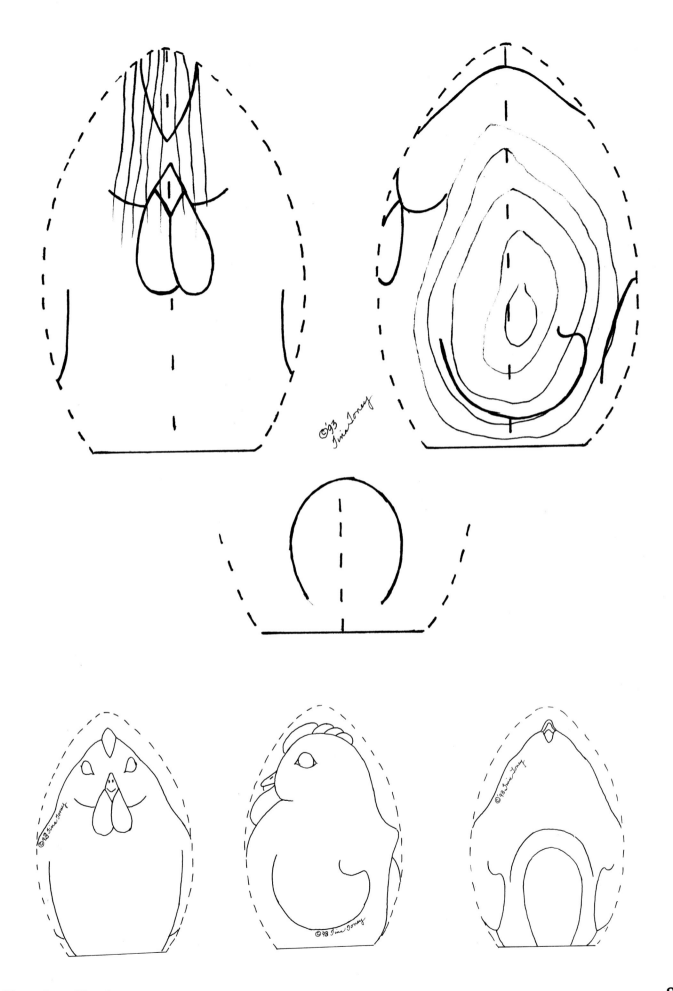

Carving Projects

Cat Carved on Goose Egg

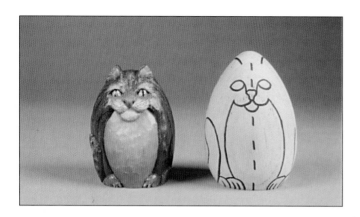

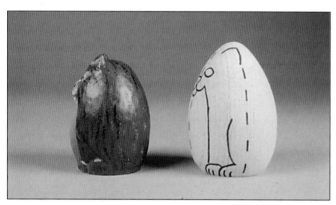

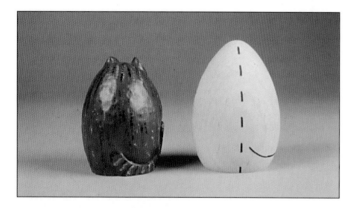

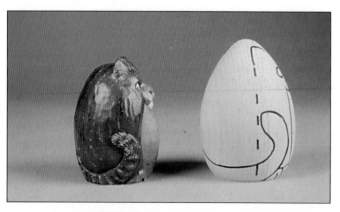

Materials: Goose egg sugar pine wood turning, 400 sandpaper grit, set of palm chisels, wood carving knife.

Paints: Trail, White, Territorial Beige, Raw Sienna, Green Sea, Black, Raw Umber, Fire Red, Jo Sonja's Rich Gold.

Mediums and Finishes: Jo Sonja's Tannin Blocking Sealer, Jo Sonja's Satin Finish Varnish, Krylon Satin Finish Varnish #1311, Trewax Clear Floor Paste Wax.

Carving Tips: Cut ¹/₂" off the bottom of the egg and sand it smooth. Place the cat face on the arch of the growth rings. Leave ample work space for the ears. Also note the variance in size between the finished piece and the turning itself. I rarely use sandpaper on sugar pine, but this piece beckoned, and I was pleased with the end results. Seal with tannin blocking sealer before painting.

Painting Tips:

- Chest: Trail as a base coat.
- Cheeks and Chin: White with Territorial Beige to make an Off White.
- Body: Raw Sienna.
- Eyes: Green Sea, Rich Gold iris, Black for the slit pupil, White highlight. Use a fan brush to apply a brindled effect with Raw Umber and Territorial Beige over the back and sides. Use Off White for stripes. Wash around the outer edges of the chest with Territorial Beige. Dry brush the Off White above the eyes and inside the ears. Shade under eyes with Territorial Beige.
- Nose: Mix Off White, Territorial Beige and Fire Red sparingly for a pink nose. Apply whiskers with a Pigma pen. Lightly mist with Krylon #1311 prior to varnish. Wax for extra patina.

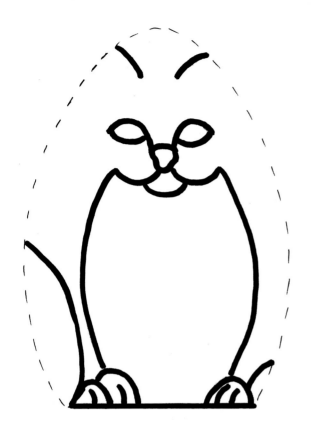

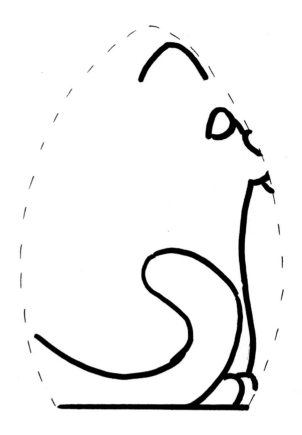

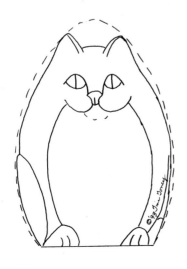

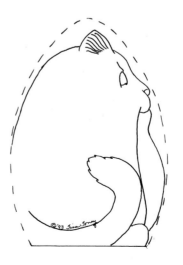

Pig Carved on Triple Yolker

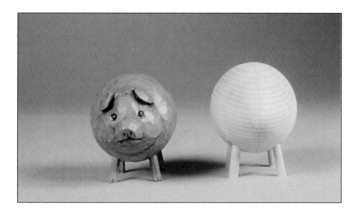

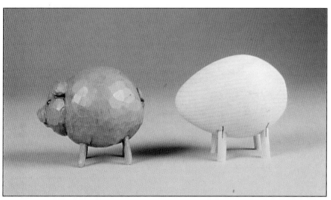

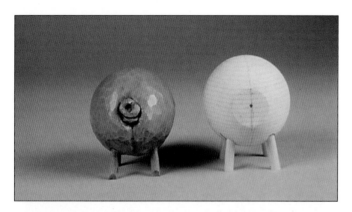

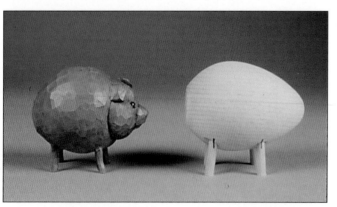

Materials: Triple yolker, 3/8" hardwood dowel, wood glue, set of palm chisels, wood carving knife.

Paints: Trail, Brown Iron Oxide, Black, White, Light Ivory, Fire Red.

Mediums and Finishes: Jo Sonja's Tannin Blocking Sealer, Jo Sonja's Retarder and Antiquing Medium, Jo Sonja's Satin Finish Varnish, Krylon Satin Finish Varnish #1311.

Carving Tips: Practice drilling pilot holes then enlarging the holes to 3/8". One practice egg provides plenty of room for experimentation. The holes should be of equal depth.

Hint: Place the egg on a hard surface. With the work firmly held down, drill at the angle you want for the front left leg. When you remove the bit, stop just above the hole, keep the drill poised in the same position, and without raising the egg from the work surface, pivot the egg clockwise to the next mark. Drill and repeat until all the leg holes have been completed.

Cut four pieces of 3/8" dowel to 1 1/4" length, apply glue and insert into the egg allowing the glue to dry. Remove small slices at the bottom of the legs until all four touch the table top.

Hint: If your workshop includes a belt-disk sander, use the disk side to even the legs. The pig should be able to stand upright with the legs glued in place before you begin to carve.

Painting Tips: Base coat the entire pig with Trail. Eyes are Brown Iron Oxide, Black and White highlight. Make a pale pink mix with Light Ivory, Fire Red (sparingly) and Trail. Use Pigma Pen to draw the eyelashes. Mist with Krylon. Antique with Black and Jo Sonja's Retarder and Antiquing Medium. Finish with Jo Sonja's Satin Finish Varnish.

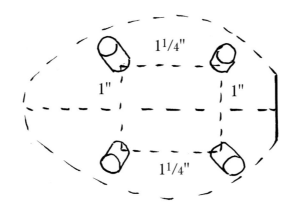

1¼" 1" 1" 1¼"

Pig Carved on Jumbo Pear

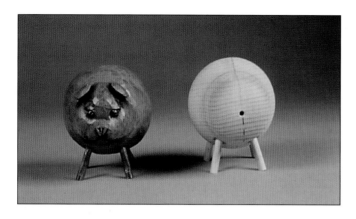

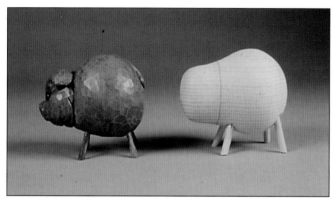

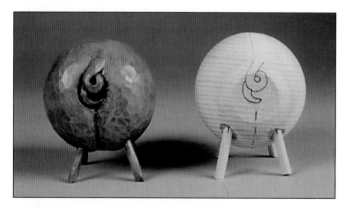

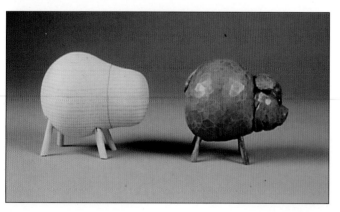

Materials: Jumbo pear-shaped sugar pine turning (or small pear for a smaller version of the pig), 1/4" hardwood dowel cut into 1 1/2" lengths, set of palm chisels, wood carving knife.

Paints: Mudstone, Brown Iron Oxide, Black, White, Light Ivory, Fire Red.

Mediums and Finishes: Jo Sonja's Tannin Blocking Sealer, Jo Sonja's Retarder and Antiquing Medium, Jo Sonja's Satin Finish Varnish, Krylon Satin Finish Varnish #1311.

Carving Tips: Locate the center line for the belly and halve the pear. Measure, draw and drill the leg hole positions. Insert uncarved dowels, glue cut and sand to finished length. The halving line should pass over the stem hole. The stem holes lower wall (wall closest to the legs) becomes the top of the pig's snout. Carve 1/4" of wood off above the snout, remove wood between the tops of the ears and shape the neck with a v-tool. Notice the angle is slightly wrong on the back leg, right side. For me, not a valid reason to quit. Placing the legs is the most difficult part of this project.

Painting Tips: Base coat the entire pig with Mudstone. Eyes are Brown Iron Oxide, Black and White highlight. Make a pale pink mix with light Ivory, Fire Red (sparingly). Use Pigma Pen to draw the eyelashes. Mist with Krylon. Antique with Black and Jo Sonja's Retarder and Antiquing Medium. Finish with Jo Sonja's Satin Finish Varnish.

Easy Weekend

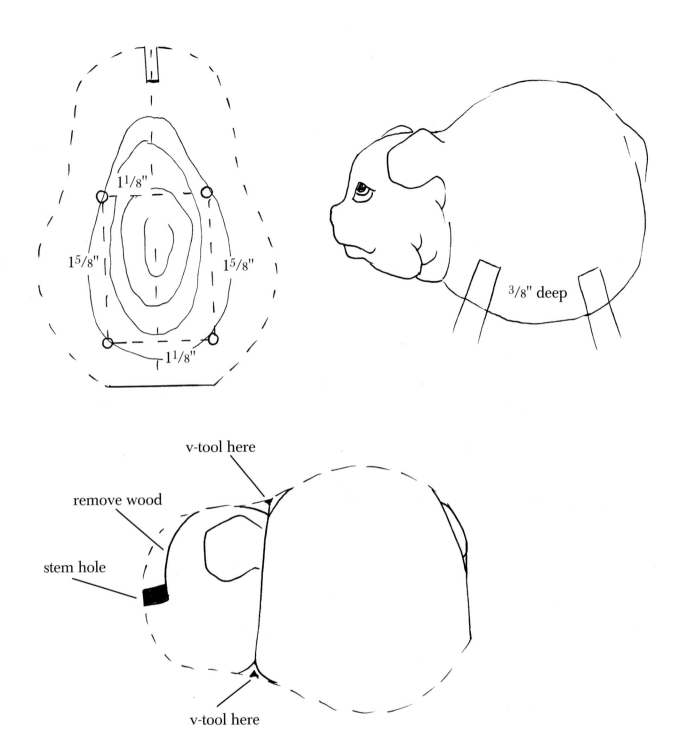

$1^1/_8"$

$1^5/_8"$ $1^5/_8"$

$1^1/_8"$

$^3/_8"$ deep

v-tool here

remove wood

stem hole

v-tool here

Daydreamer Carved on Triple Yolker

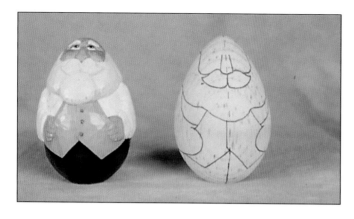

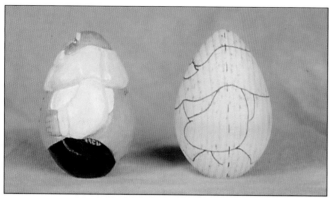

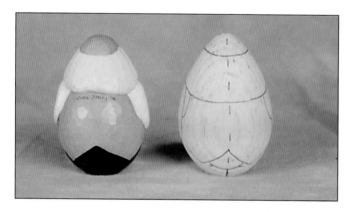

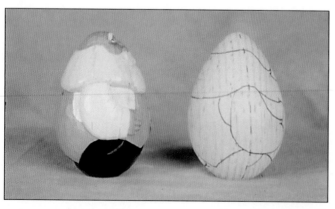

Materials: Triple yolker sugar pine turning (or any size egg of your choice), Pigma .005 Permanent Pen, set of palm chisels, wood carving knife.

Paints: White, Charcoal, Mudstone, Black, Rouge, Bonnie Blue, Antique White.

Mediums and Finishes: Krylon Satin Finish Varnish #1311, Jo Sonja's Tannin Blocking Sealer, Jo Sonja's Flow Medium, Jo Sonja's Satin Varnish, Trewax Floor Paste Wax in Indian Sand and Clear.

Painting Tips: The Daydreamer's face, head and hands are Rouge diluted to a wash with Jo Sonja Flow Medium. The eyes are painted White, Bonnie Blue for the iris, Black pupil and White highlight. The hair is Antique White, Mudstone for the vest and Charcoal pants shaded with Black. Outline the eyes with a Pigma .005 pen. Allow the paint and the ink to dry. Using Krylon, lightly mist the face area to set the ink before sealing with Jo Sonja Satin Varnish.

Finishing Tips: Antique with Trewax Floor Paste Wax in Indian Sand using a soft cloth and tooth-brush. Immediately use the Trewax Floor Paste Wax in Clear, removing the excess Indian Sand until the desired effect is achieved. Do not allow the wax to dry more than three minutes before buffing.

Easy Weekend

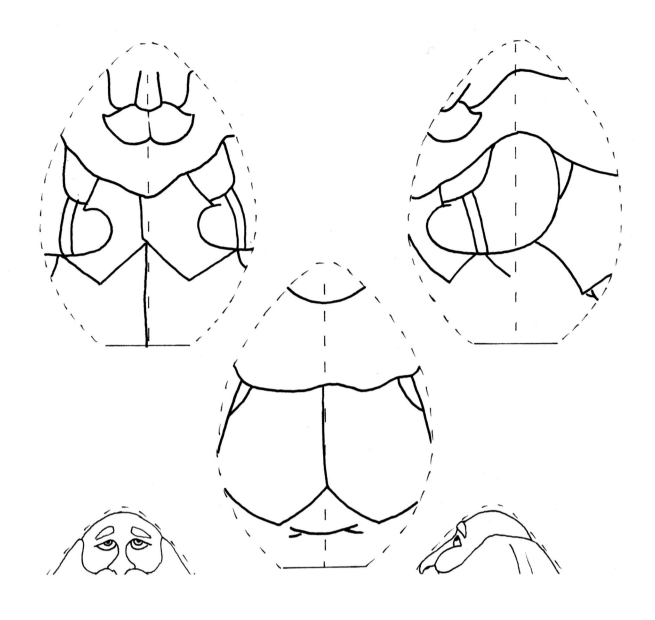

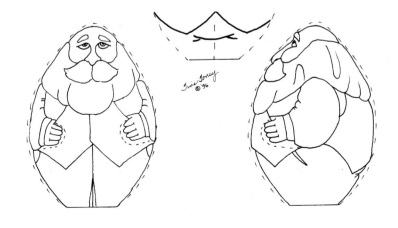

Santa Carved on Small Pear

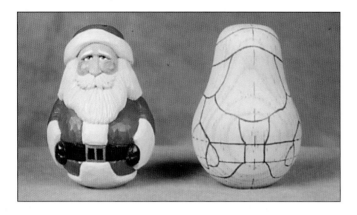

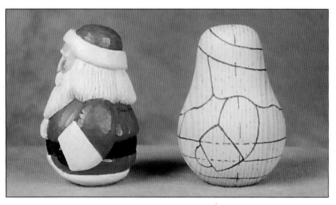

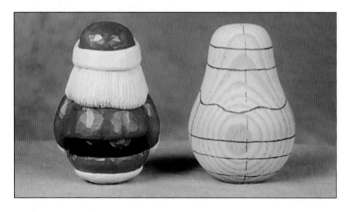

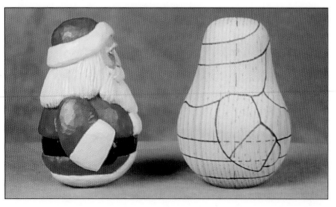

Materials: Small pear-shaped sugar pine turning, wood filler or wood dowel.

Paints: White, Antique White, Ivory, Rouge, Black, Tomato Spice, Bonnie Blue, Jo Sonja Rich Gold.

Mediums and Finishes: Jo Sonja Flow Medium, Jo Sonja Satin Finish Varnish, Krylon Satin Finish Varnish #1311, Jo Sonja Tannin Blocking Sealer.

Carving Tips: This pear was drilled for a stem on the top. Use wood filler or a wood dowel of appropriate size to fill it in.

The exercises starting on page 5 are shown on a similar Santa carved on a small pear. The difference between the two Santas is that the belt on this project is squeezing Santa's ample waist. This Santa requires the removal of the belt wood before shaping the bulging waist and clothing. The hair, mustache and beard were detailed with the v-tool.

This project has carved eyes, not easily accomplished by the novice wood carver. If you lack the confidence to attack this eye, carve a flat area and paint the eyes.

Painting Tips: I used the natural color of the sugar pine as the flesh tone. The cheek color is layered, allowing each layer to dray thoroughly before another layer is applied. Should you not allow for this, the brush will pull off the previous paint layer creating splotchy patches. The rosy cheeks are achieved by mixing Rouge with Jo Sonja's Flow Medium to a wash. Pre-moisten the cheek area lightly with clean medium. Apply the Rouge mix sparingly, fading the color outward. Build the cheek color layer by layer until the cheeks are the intensity you want. This procedure will allow the wood grain to be visible through the cheek color.
- Eyes: White with Bonnie Blue iris, Black pupil and White highlight. Outline the upper lids for added effect.

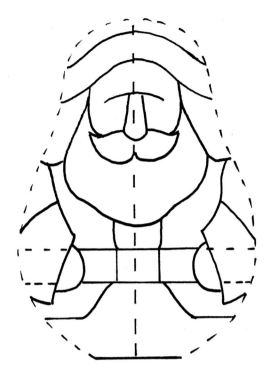
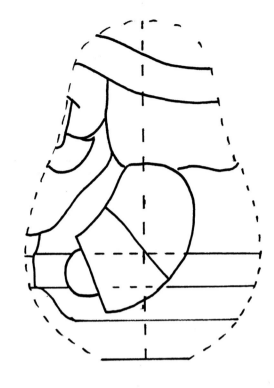

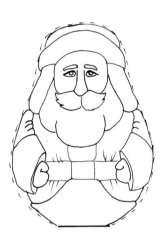
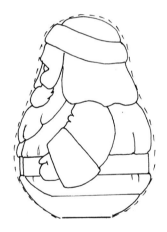

- Beard and Hair: Antique White.
- Fur Trim: Ivory.
- Clothing: Tomato Spice.
- Mittens and belt: Black with Jo Sonja Rich Gold for the buckle.

Finishing Tips: Lightly mist the face area with Krylon Satin Finish Varnish #1311 and allow it to dry completely. Seal the carving with Jo Sonja's Satin Finish Varnish before antiquing with Trewax Floor Paste Wax.

 # Titles From Fox Chapel Publishing

DESIREE HAJNY TITLES

Big Cats by Desiree Hajny
NEW! Carving Lions, Tigers and Jaguars. Desi's new full color guide to carving these majestic predators. 100's of color photos and anatomy charts guide you through creating your own masterpiece. Also features painting instructions and reference photos of live animals.

$14.95

Mammals:
An Artistic Approach
by Desiree Hajny (second printing)
Carvers will learn to carve realistic North American mammals - deer, bear and otter in this informative 150 page book. Carving techniques for both hand tool and powercarvers are covered plus much needed info on texturing, woodburning and painting.
$19.95

Carving Caricature Animals
NEW! **by Desiree Hajny**
Learn how to make caricature carvings based on real animals. Desi shows you how to use cartooning techniques to emphasize an animal's most recognizable characteristics – and then turn those ideas into a caricature carving. Includes over 100 color photos, step-by-step carving and painting techniques, and patterns.
$14.95

Carving Small Animals
NEW! In this comprehensive book, Desi includes everything you'll need to carve rabbits, racoons and squirrels. Anatomy sketches, descriptions of the animals, and reference photos give you a detailed look at your subject. Charts and photos outline techniques for carving and painting in a step-by-step fashion. Includes patterns, too!
$14.95

MARY DUKE GULDAN TITLES

Mary Duke Guldan has been writing and illustrating the ¡Lets Carve¡ column here in Chip Chats for over a decade. The books below offer expanded and revised material.

Woodcarver's Workbook
Carving Animals with Mary Duke Guldan
Called the "best woodcarving pattern book in 40 years" by NWCA president Ed Gallenstein. Carving instructions and detailed information on 9 realistic projects including dogs, moose, wolves, whitetail deer, wild horses & more.
$14.95

Woodcarver's Workbook #2
All new projects (no repeats from book #1 above). Projects inside: Native Indian Chief, buffalo, elk, horses, mules, cattle and oxen, plus a country farmer pattern.
$14.95

CARICATURE CARVERS OF AMERICA (CCA)

Carving The Full Moon Saloon
Caricature carvers will delight in the work of this group of great carvers. 21 members including well known teachers like Harold Enlow, Claude Bolton, Steve Prescott, Desiree Hajny, Tom Wolfe and Jack Price. Together, these members created "The Full Moon Saloon" a scale model measuring 4 feet long and containing over 40 carvings. Carving the Full Moon Saloon is a 120 page color guide to the creative work involved in these characters. Close up photos show incredible details. Includes patterns and painting technique section.

THE book for Caricature Carvers **$19.95**
Hardcover edition (quantities limited) **$29.95**

STEVE PRESCOTT TITLES

Carving Blockheads by Steve Prescott
What is a Blockhead? A Blockhead is a basic shape roughout that can be carved into infinite character-filled personalities. Join Steve as he carves a basic blockhead and then features patterns and color photos of 50 more Blockheads - doctors, nurses, policeman, gnomes...and many more. An exciting new look at carving! **$12.95**

Cowtown Carving
Carving Characters with Texas Whittling Champion Steve Prescott.
15 projects including Cowtown Santa, Rodeo Clown and lots of cowboys! Steve includes both a full size bandsaw roughout pattern and a detail pattern for each project. Good pattern book for the intermediate + carver. **$14.95**

Whittling Old Sea Captain and Crew
NEW! **by Mike Shipley**
An exciting book on caricature style from this Ozarks Mountain carver. Over 100 photos and color painting guide plus patterns.

$12.95

JIM MAXWELL TITLES

Ozarks carver Jim Maxwell has been teaching and carving around Branson, MO for over 25 years. Jim's work shows clean lines, smooth finish and original patterns. Recently, we've started producing roughouts (see below) of his most popular projects.

Carving Clowns with Jim Maxwell
Over 200 b/w and color photos introduce you to the humorous world of clowns. Complete how to information for carving and painting. Patterns for 12 different clowns included inside. Highly Recommended! **$14.95**

Woodcarving Adventure Movie Characters
An excellent how to carve book using characters from Jim's favorite silver screen heroes as inspiration. Carve a sailor, cowboy or 21 other exciting characters. All patterns included inside. Over 150 step-by-step photos. **$12.95**

Carving Characters
12 favorite projects including Jim's famous Turkey Buzzard.
$6.95

Making Collectible Santas
and Christmas Ornaments
8 creative Santas and 34 ornament patterns. **$6.95**

Maxwell Roughouts
(#RO1) Roly Poly Santa (5") tall, **$6.00**
(#RO2) Snowman (4") tall, **$6.00**
(#RO3) Butterfly Catcher (Emmett Kelley-type) 10" tall, **$15.00**
(#RO4) Auguste - style - classic clown style 8" tall, **$15.00**

BIRD CARVING TITLES

Carving Hummingbirds
NEW! **by Chuck Solomon and David Hamilton**
Full color guide to carving and painting "hummers". Patterns for broadtail and ruby throat included. 100's of photos in full color. Reference material on anatomy, wings and habitat. Highly Recommended! **$19.95**

GEORGE LEHMAN CARVING PATTERN BOOKS

Minnesota carver George Lehman's pattern books are a very useful source for beginning and intermediate carvers. Tips, sketches and techniques are sprinkled throughout each book. Four volumes available:

Book One:
Carving 20 Realistic Game and Songbirds
Partial list: common loon, chickadee, owl, mallard, grouse, robin, pintails. **$19.95**

Book Two: Realism in Wood
Partial list: bald eagle, kingfisher, pheasants, bobwhite, great horned owl, pileated woodpecker, red-tailed hawk, mockingbird.
$19.95

Book Three: Nature in Wood
Partial list: barnswallow, cardinal, warblers (3), wrens, goldfinch + 10 animal patterns. **$16.95**

Book Four: Carving Wildlife in Wood
Partial list: Canada goose, wild turkey, osprey, Baltimore oriole, great blue heron. **$19.95**

Encyclopedia of Bird Reference Drawings
by David Mohardt
Detailed sketches, wing studies and reference info for carvers. 215 different varieties of birds covered. Recommended by Larry Barth, Bob Guge. **$14.95**

Carving Fish - Miniature Salt water and Freshwater
by Jim Jensen
These detailed patterns, woodburning tips, color painting sections and step-by-step photos show you how to carve 26 different miniature fish for sale or display. **$14.95**

Carousel Horse Carving
An instruction workbook by Ken Hughes. Recommended as a classic how-to on carving carousel horses. Ken shows you everything step-by-step in making a denzel style carving in 1/3 standard size. Over 150 photos. New edition includes full size fold out pattern.

$24.95

Carving Vermont Folk Figures with Power
by Frank Russell, the Author of "Carving Realistic Animals with Power" offers an exciting collection of characters from The Bachelor to The Logger ready to use patterns included. **$9.95**

Fantastic Book of Canes, Pipes and Walking Sticks
by Harry Ameredes
This WV Artist and carver has made canes simple and decorative for over 30 years. In these hundred of detailed drawings you'll find lots of ideas for canes, weathered wood and pipes. Plus info on collecting tree roots. **$12.95**

Bark Carving by Joyce Buchanan
Learn to harvest and carve faces - mystical woodspirits and other expressions in bark colorful guide with pattern and lots of helpful info. **$12.95**

Sculpturing Totem Poles by Walt Way
Easy to follow pattern and instruction manual. Lots of clear drawings plus three patterns inside. **$6.95**

Carving Wooden Critters
Diane Ernst carves appealing animals that are best described as realistic caricatures. 16 high quality patterns for rabbits, puppies, otters and more. **$6.95**

JUDY GALE ROBERTS INTARSIA BOOKS

Intarsia is a way of making picture mosaics in wood using 3/4" lumber. Carvers can further enhance their intarsia pieces by selective detailing.

Easy to Make Inlay Wood Projects
The best introduction to intarsia. Over 100 photos show you how it is done. Also includes 12 free patterns and 30 color photos. **$19.95**

Small Intarsia Projects
NEW! Full color guide with 12 patterns for a wide variety of pieces. **$14.95**

300 Christian and Inspirational Designs
NEW! Although written for scroll saw users, this book will be most helpful for carvers looking for designs to carve both in relief and in the round. **$14.95**

Mott Miniature Furniture Workshop Manual
Ready to use pattern for 144 scale model furniture projects. Best book on the subject. **$19.95**

TOLL FREE 1-800-457-9112

HOW TO ORDER:
CREDIT CARD ORDERS MAY CALL **1-800-457-9112**
MAIL ORDERS PLEASE SEND BOOK PRICE PLUS $2.50 PER BOOK
(MAXIMUM $5 SHIPPING CHARGE) TO:

Fox Chapel Publishing
PO Box 7948 Lititz Pike
Lancaster, PA 17604-7948
FAX (717) 560-4702

Dealers write or call for wholesale listing of over 800 titles on woodworking and carving